11.00

EL GRECO

EL GRECO

JACQUES LASSAIGNE

164 illustrations
52 in colour

THAMES AND HUDSON
LONDON

ENGLISH TRANSLATION BY JANE BRENTON

ND813
T4
L2913

*English translation © 1973
THAMES AND HUDSON LTD, LONDON
© 1973 Editions Aimery Somogy S.A., Paris*

*Printed in Spain
Photoset by Trade Spools, Frome, Somerset*

ISBN 0 500 18142 x cloth
ISBN 0 500 20136 6 paper

Contents

El Greco's Background

One of the few facts we know for certain about El Greco is the exact date of his death. Otherwise there is very little information about the life of this intriguing personality who, although of Greek origin, became one of the greatest painters in the history of Spanish art. The date of his birth can be deduced from his own statement at the time of the Illescas lawsuit, in 1606, when he said that he was sixty-five years old.

We know then that Domenikos Theotokopoulos was born in Crete, as many signatures to his paintings indicate, in 1541. It is not known exactly where he was born, but it is reasonable to accept the evidence of two crucial documents that it was in the province of Candia [1]. In a letter to Cardinal Farnese, written in November 1570, the miniaturist Giulio Clovio recommends to him a 'young Candiote'; and in May 1582, when El Greco acted as interpreter for a Greek called Michel Rizo, being tried by the Inquisition in Toledo, he described himself under oath as 'a native of the town of Candia'. However there is also a rather tenuous theory that his family home was the little village of Phodele, near the island's capital.

The only evidence relating to his family is a lead seal in the Numismatic Museum in Athens, inscribed 'Seal of Manuel, of the Theotokos family' in fourteenth-century script. The family originated in Byzantium, then went to Corfu and on from there to Crete.

Documents found in Venice prove that the branch of the Theotokos family established in Crete was of considerable wealth and consequence. Perhaps because of difficulties of pronunciation, the name Theotokopoulos (Son of God) has undergone many transformations, from the original Domenikos Theotokopoulos to the Spanish version, Domenico Theotocopouli, or Dominico Greco, or simply El Greco, as we know the painter today.

Any discussion of El Greco's early grounding in Byzantine art must be highly speculative. There is little information about sixteenth-century Venetian-Cretan painting as most of the works of art and monuments of the period were destroyed by Turkish vandals. Those works that have survived tend to show a strong Byzantine tradition persisting in all Greek painting of the time.

Historians with a developed sense of imagination inform us that El Greco spent his childhood in the village of Phodele and was then taught by the monks of St Panteleimon, before completing his education at the famous school attached to the Monastery of St Catherine, a dependency of the Monastery of Mount Sinai. Attempts have been made to establish links between the work of El Greco and that of an extremely interesting Cretan painter called Mixai'l Damaskinos; any conclusions that can be drawn are of dubious validity.

Judging by what we know of El Greco's love of philosophical writings, classical literature, religious studies, works on geography, history and art (as revealed by the inventory of the contents of his library), it seems

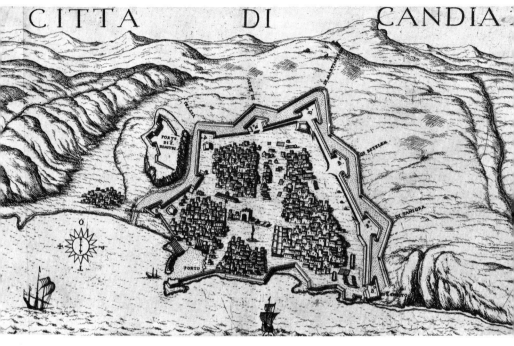

1 ANONYMOUS *View of Candia* 1582

likely that he grew up in a family belonging to the
local aristocracy. His humanism was probably the
result of a liberal education, and indeed even his earliest
paintings reflect some awareness of Italian culture, such
as one might expect to find in one of the leading
Candian families. One can also deduce that El Greco
must have belonged to the Catholic community, as
the many references to theology and ritual in his early
works follow a typically Western iconography.

9

Equally it should be noted that Byzantine influences and themes occur in his pictures in every period of his life; it is only his Italian handling that on occasion makes this less than obvious.

Many critics have pointed out the compositional similarities between certain paintings by El Greco and the works of Theophanes of Crete or of Damaskinos, who painted icons for the cathedral at Candia and a mural in Venice. The angel seated on the Holy Sepulchre in *St Peter in Tears* is the same figure as the angel in Damaskinos's *Noli me tangere* in the metropolitan church of Candia. The scene representing the stoning of St Stephen, painted on the dalmatic in the *Burial of the Count of Orgaz*, resembles the depiction of a stoning in the mural painted by Damaskinos for the Church of San Giorgio dei Greci in Venice. The composition of the *Pentecost*, the typical elongated rectangular format with the figures lined up against the two long sides, is the same as is seen in many Byzantine icons. The development of the main theme in a number of subsidiary scenes, as in the *Martyrdom of St Maurice*, the *Agony in the Garden*, the *Espolio* and many other works, is clearly derived from Byzantine icons and miniatures. The oval grouping of the figures, as in the *Coronation of the Virgin*, also comes from the Oriental tradition. There is also an uncanny resemblance between El Greco's faces, with their heavily accentuated main features and concentrated expressions of ecstasy, and the Græco-Egyptian portraits of the Fayum painted in the second or third century A D.

There are many more points of resemblance between the works of El Greco and their Byzantine counter-

parts. Whether consciously or not, El Greco echoes the spirit of Byzantine mosaics, even in the techniques of brushwork he uses to achieve his glowing, dazzling, brilliant colours. There are clear parallels in the way the figures are handled, but it is in the treatment of light that the similarities are most marked. Like the Byzantines, El Greco paints light that is drained of warm solar tones and takes on the pallor of moonlight.

El Greco never abandoned the Byzantine practice of first covering his painting surface with a coat of white, ochre, black or green, then drawing in lines to divide the picture into sections, and finally painting in each separate entity in turn, waiting for one layer of paint to dry before applying the next. This was why he always had quantities of unfinished sketches in his studio, a fact which made a strong impression on Pachecho. The Byzantine influence is also apparent in his arbitrary foreshortening of perspective, the shallow construction of space in his pictures, and the deliberate positioning of figures in the foreground against a very low horizon, so that they take on the appearance of ghostly apparitions.

It has even been suggested that El Greco should not be seen as part of the history of Spanish painting at all, and that his Byzantine culture finds expression in works of Italian form. Mayer maintains (*Art Bulletin*, 1929) that his spatial abstraction and magical interpretation of perspective are Oriental in origin. Spanish art is essentially concrete and direct, drawing on elements of real life for inspiration (still-lifes being particularly highly regarded), while El Greco inhabits a spiritual realm, giving expression to ideas and emo-

tions and filling his universe with divine and supernatural presences. By these means he arrives at an unreal, indeed other-worldly conception of distances and volumes, so that even if the forms and perspectives in his mind's eye are typically Byzantine, they emerge as something completely original. Yet one must take into account the mediocrity of his Italian works, which remained no more than 'spiritual sketches'; it then becomes apparent that this tendency became marked only in the course of close and prolonged contact with Spanish mysticism.

Judging by what we know of his friends and reading habits in Toledo, El Greco retained a strong affection for his native country. He always signed his name in Greek, sometimes adding the word KRHS, which means Cretan. Even in 1579 he cannot have understood Spanish all that well, as he asked for a copy and translation of his evidence at the trial concerning his payment for the *Espolio*. As he grew older he associated more and more with other Greeks. He had living in his house a relative, who may have been his elder brother, called Manoussio Theotocopouli. El Greco's will was witnessed by two Greeks, Doctor Diogenes of Parromonlio and Konstantino Phocas, both presumably his friends.

The contents of his library in the year of his death, as revealed by the inventory drawn up by his son Jorge Manuel, give us a valuable insight into the artist's personality and character. It would appear that Jorge Manuel was guided by his father's order of preference when he listed all the Greek books first.

Early Influences

Not a single work has survived from the artist's early years in Crete, none at least that can be attributed to him with certainty. If it was in Crete that he produced his first pictures as an apprentice icon-painter, then his output must have been indistinguishable from the stylistic uniformity of the Byzantine panels of the period.

El Greco betrays his Byzantine origins less in an adherence to the accepted art forms of contemporary Greek painters than in his enduring and deep-seated antipathy to the fundamental principles underlying the Western painting of the time, and this is true even of his Italianate works. There is no evidence whatsoever to suggest that he studied the frescoes of Mount Athos or of Mistra at first hand, and the parallels between his own paintings and those in the monasteries must be due to the availability of copies in Venice. Numerous Greek painters of devotional images of the Madonna, the so-called 'Madonneri' lived on the Rialto. By 1550 there were as many as four thousand Greeks in Venice, whose place of worship was the Church of San Giorgio dei Greci on the Rio dei Greci. The confrontation of the native art of these Greek painters with the prevailing artistic trends in Venice produced the Scuola Byzantina Migliorata, probably the source of inspiration for some of El Greco's earliest works. Certainly these indicate an Oriental temperament expressed in forms that are fully

Italian in character. The Byzantine atmosphere of the paintings has little to do with the traditions of Greek ideal figure art, but derives from the adaptation of set Venetian, and later Roman, formal schemes to Eastern ideas.

Nothing could be a greater contrast to the hieratic and traditional art of a true Byzantine painter, like Damaskinos, than the linear innovations and highly inventive spirit of El Greco's early works. In fact there are very few concessions to Byzantine theories of art in the paintings done before his Spanish period. It was in Spain, and in particular towards the end of his life, that his Byzantine vocation expressed itself most forcefully. The types he created then were handled with all the flexibility permitted by Western techniques but also had characteristics derived from Greek art; this is perhaps an example of a not uncommon phenomenon whereby an artist returns in later life to the influences and impressions of his youth.

It does therefore seem likely that El Greco learned the rudiments of his art in Crete, for example his method of synthesizing the most expressive facial characteristics, by drawing separate lines of bright colour in such a way as to make them stand out distinctly from their background. And it would have been in Crete that he acquired the habit of preparing his panels with the pale grounds that give his Italian paintings their shiny lacquered effect.

Arriving in Venice as a young man, he would have found it quite easy and natural to adapt Italian forms to Byzantine patterns, as in the *Modena Triptych*. His Byzantinism is therefore best explained as a resurgence

2 *Modena Triptych: Annunciation, Mount Sinai, Adam and Eve* 1561–65

3 *Modena Triptych: Adoration of the Shepherds, Allegory of a Christian Knight, Baptism* 1561–65

of certain native characteristics within Renaissance forms and in spite of his Italian education. This resurgence became more marked as he grew older, and towards the end of his life the Italian forms faded and disappeared and his Byzantine vocation came to the fore, by this time reduced to a set of basic aesthetic principles, refined by his personal genius and incorporating some of the Western forms he had by then fully assimilated. It is precisely this Byzantine resonance that gives El Greco's work its individual and obsessional character.

El Greco in Venice

It is probable that El Greco arrived in Venice while still quite a young man, probably in about 1560. This city was, for the Cretans, not just a metropolis of the arts and literature, but also a political capital. The work of artists and craftsmen was very popular with the Venetians, and so many of them came to the city that they formed their own trade guild.

There is contemporary evidence to suggest that El Greco was a pupil of Titian. The letter written by the miniaturist Giulio Clovio to Cardinal Farnese in 1570 recommends to him 'a young Candiote, pupil of Titian'; and in a letter to Philip II, of December 1567, Titian makes reference to a young foreign painter. (It was presumably as a result of this letter that El Greco later had dealings with the King, a far from happy association as it turned out.) These two documents provide the only certain proof of the link between the two painters. It is difficult to trace the pattern of El Greco's development during his time in Venice as there are few pictures from this period that can be attributed to him with certainty.

There are a few works from an early cycle (1561–65) in which the painter uses Greek techniques to embody Italian forms: *Glorification of a Doge*, the *Modena Triptych* [2, 3, 6], and the *Flight into Egypt* [4]. It is just possible that he had connections with Jacopo Bassano's studio during this period: although his attempts to

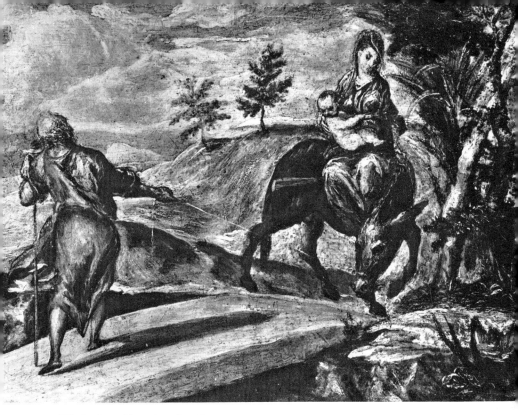

4 *Flight into Egypt* 1561–65

match the naturalism of Bassano's stocky, seated
peasant women amount to no more than clumsy
imitations, there can be no doubt that he knew of his
studies in luminosity, even though he himself took care
not to lose sight of his precious grounding in Byzantine
culture.

El Greco made use of pictures and engravings to help
him introduce a Western element into his composi-
tions: one can detect borrowings from engravings by
Caraglio, Bonasone, Parmigianino, Schiavoni, Dürer
and many others. The parallels with Bassano's work

5　*Day* 1565–66

are so striking that it seems by no means improbable
that they worked together. Bassano himself got inspira-
tion from the engravings by the German Barthel
Beham. The Byzantines followed the same procedure:
The *Massacre of the Innocents* by Theophanes of Crete

18

was copied from an Italian engraving by Marco
Antonio Raimondi.

In his second Venetian phase, lasting only a few
months in *c.* 1565–66, El Greco was greatly influenced
by Tintoretto, probably attending his studio, and was
already painting in the Venetian style. The works of
this period are more serene in inspiration and the
painter uses perspective and groups his figures in a

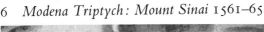

6 *Modena Triptych: Mount Sinai* 1561–65

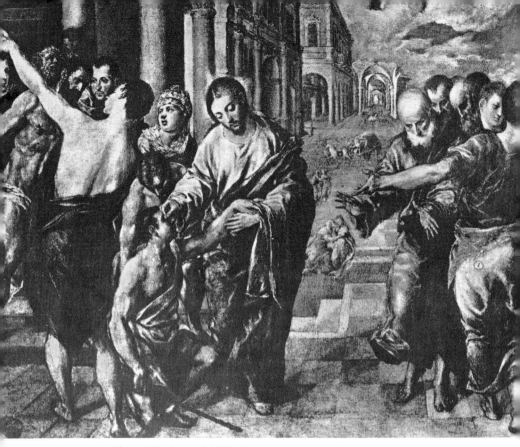

7 *Christ Healing the Blind* 1567–69

calculatedly Western manner. These traits are exemplified in his copy of Michelangelo's *Day* [5], the *Adoration of the Kings* [10], the *Purification of the Temple* [13] now in Washington, and the version of *Christ Healing the Blind* [12] now in Dresden; perhaps also of this period are two pictures now in Strasbourg, *Christ and the Woman Taken in Adultery* [9] and the *Marriage at Cana* [8], although their attribution to El Greco is sometimes disputed.

Tintoretto's temperament was certainly much more in tune with El Greco's. He learned from the Venetian painter how to compose his figures in groups, how to make them come alive by setting them against an architecture that echoed their rhythms, and how to manipulate them in space without relying on the conventional laws of visual perspective. And El Greco never abandoned the practice he learned from Tin-

8 *Marriage at Cana* 1565–66

9 *Christ and the Woman Taken in Adultery* 1565–66

toretto of painting from little models, which he sculpted himself out of wax or wood, and which he could arrange as he wished in a given setting. Veronese was another source of inspiration, encouraging him to experiment with more rounded forms and to develop a feeling for rich materials and certain colours, green in particular. And, finally, Titian passed on to him his mastery of painting technique.

The third phase is dominated by this great master and from 1567 to 1569 he was El Greco's model and

inspiration. The Greek painter modified both his technique and his ideas of form. His loose, sketchy brushstrokes merged together to form more compact surfaces.

Paradoxically, Titian's influence seemed at first to mark a retrograde step in El Greco's development: the figures become more corporeal, their beauty more fleshy, surfaces more rounded, the brushstrokes smoother and more harmonious. These changes become apparent if one compares the Parma *Christ Healing the Blind*, which is of this period, with the earlier Dresden version of the same theme. The later picture comes closer to the classical ideal, but the figures are of reduced proportions and have lost the nervous energy and drama of the first version. Under Titian's influence even the colours are darker and more evenly blended.

The *Adoration of the Kings* [10], today in the Benakis Museum in Athens, is a small signed panel, painted in tempera on the reddish ground normally used for icons. The composition includes several figures and is completely Italian in spirit with no trace of Byzantine influence.

The *Glorification of a Doge*, a painting on slate attributed to El Greco, contains elements that were to be developed in El Greco's later work; for example the division of the composition into two zones, one terrestrial, the other heavenly. This work dates from 1560–62.

The *Modena Triptych* [2, 3, 6], discovered by R. Pallucchini in 1937 in an attic of the Galleria Estense, Modena, is signed 'by the hand of Domenikos'. It is a

10 *Adoration of the Kings* 1567–69

small portable altar comprising six panels: the *Adoration of the Shepherds*; the *Allegory of a Christian Knight*; the *Baptism*; *Adam and Eve*; the *Annunciation*; and *Mount Sinai*. In terms of iconography the *Annunciation* and the *Adoration of the Shepherds* are the most interesting, as they are both themes El Greco returned to towards the end of his life, although in a highly personal and original style that is far removed from the influences of his youth.

24

Mount Sinai [6] foreshadows the visions and strange imaginings of El Greco's paintings towards the end of his life. The landscape is of imposing splendour, with three curiously shaped mountains and Moses above them receiving the Tablets of the Law. Against the slope of the central mountain is a walled monastery and, at the foot of the panel, figures, apparently pilgrims on their way to Jerusalem, insubstantial moving forms.

11 *Adoration of the Kings c.* 1570

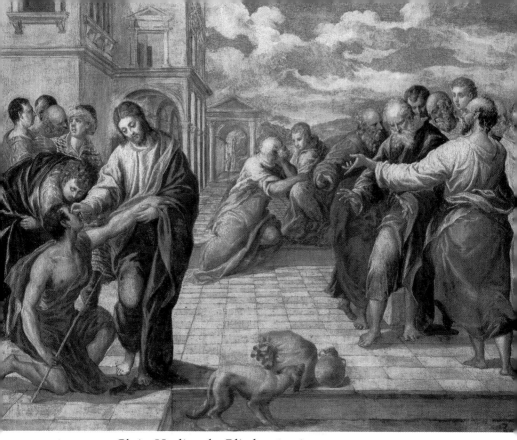

12 *Christ Healing the Blind* 1567–69

The triptych is painted in tempera treated so as to give
the effect of lacquer or enamel. The date is very un-
certain, Pallucchini suggests 1567, and Aznar
somewhere between 1563 and 1567.

Even less certain is the date of another version of
Mount Sinai which was formerly in the Hátvany
Collection, Budapest, and is probably the panel owned
by Fulvio Orsini and listed in the inventories of the

Farnese Palace as being 'di mano d'un greco scolare de Titiano'. Its close resemblance to the panel in the *Modena Triptych* makes it reasonable to suppose that the two works are contemporary.

Another *Adoration of the Kings* [11], today in the Museo Lázaro Galdiano in Madrid, is one of the finest works of the painter's Venetian period. It is a panel, also painted in tempera, as brilliant as enamel, the brushstrokes swift and energetic, the films of paint so transparent that the colours shimmer. The composition is in the style of Bassano but the colouring is derived from Byzantine techniques.

The *Adoration of the Shepherds*, in the Willumsen Collection in Copenhagen, is a variation on an engraving made in 1567 by Cornelis Cort, after a painting by Taddeo Zuccaro. Already it contains hints of El Greco's mature personality and, unlike the previous works, shows a marked Venetian influence.

Boldrini's engraving after a drawing by Titian was El Greco's inspiration for *St Francis and Friar Leo*, which shows the painter attempting to simplify his composition by eliminating inessential details. He painted many variations on this subject in his last Spanish period.

The first version of the *Purification of the Temple* [13], in the National Gallery, Washington, is signed and is given a probable date of 1566–68 by Aznar, or 1571 according to Mayer. It is a complex and imposing composition with very elaborate architectural details and reveals a clear debt to Tintoretto and Titian. The poses of some of the figures are also reminiscent of Bassano and Raphael. As in the previous picture, pale tones predominate.

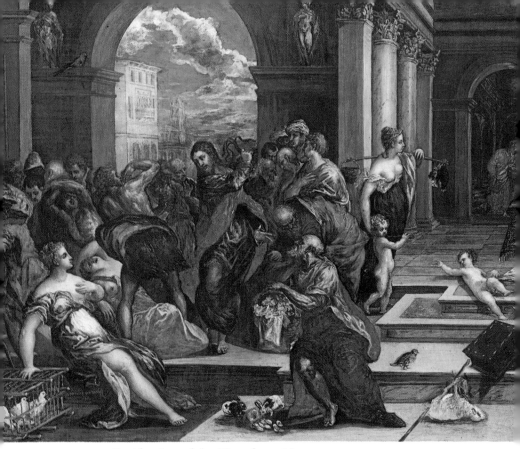

13 *Purification of the Temple* 1566–71

In the Bologna *Boy Lighting a Candle* (El Soplón),
the first of his paintings to use this motif, the influence
of Bassano and Titian is apparent. This early attempt
at Popular Realism and use of candlelight effects
anticipate certain elements of El Greco's work in Spain.
There is a second version, now in a private collection
in New York, and a third, which must be of later date,
in the Naples Museum [14].

The second version of *Christ Healing the Blind* [7],
in the Pinacoteca in Parma, is not easy to date accurately,

but it is believed to have been painted at the end of El Greco's time in Venice or even soon after his arrival in Rome. The composition is more concentrated, attention is focused on the foreground elements, and the architecture is reduced to a simple background decor.

El Greco's youthful works show many very diverse tendencies, indicative of a temperament searching to discover its true direction. The most advanced show a rapidly acquired mastery of Venetian principles:

14 *Boy Lighting a Candle (El Soplón) c.* 1575

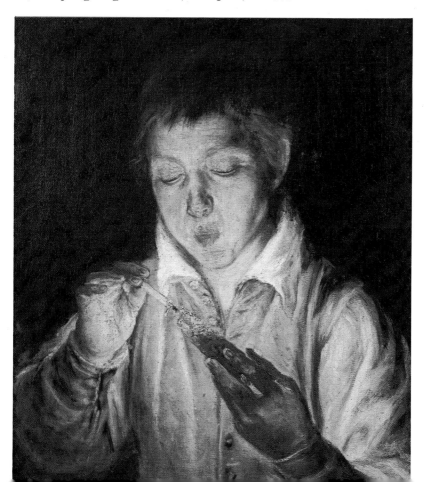

three-dimensional architecture, full and rounded forms, flowing rhythms. They are not unlike the paintings of Veronese or even of Correggio (whose pictures El Greco also copied), and they represent an important stage in his development, though ultimately they do not lead anywhere. The Dresden and Parma versions of *Christ Healing the Blind* make El Greco look like a competent, middle-of-the-road Venetian painter. The studies of artificial lighting and people lighting candles are not central. Later El Greco integrated luminosity with colour; it became a manifestation from within, not an outward display.

El Greco in Rome

There could be no better illustration of El Greco's interest in the great works of art of his time than his fine drawing after Michelangelo's *Day*. El Greco has conveyed admirably the three-dimensionality of the sculpture and, clearly, was attracted to the subject by the sense of rhythm that sweeps through the forms. It is not therefore surprising that, having exhausted the lessons to be learned in Venice, he should have thought of going to Rome in search of new artistic horizons. His journey took him to Parma and Reggio (where he copied Correggio's *Night* in his own very personal style), and possibly to Florence. But very little is known about the journey to Rome, not even its exact date, 1568 or 1569.

At that time Mannerism was the prevailing fashion in Rome. The great Roman art of the first half of the sixteenth century had come to an end with the fresco painters who took their inspiration from Raphael and Michelangelo. By 1570 there were only mediocre disciples who did no more than re-work Michelangelo's subjects, painters who were not much more than decorators, skilled in composition but lacking creative genius. There was, for example, Vasari, also El Muziano and Federico Zuccaro, several of whose works are in the Escorial. To some extent they had an influence on El Greco, yet he remained fundamentally different as he retained the practice of using short,

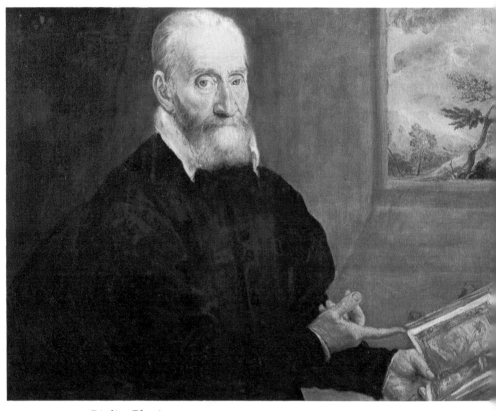

15 *Giulio Clovio c.* 1570

nervous brushstrokes, which he had learned in Venice,
and his more agile and supple manner was in marked
contrast to the smooth surfaces and unbroken expanses
of colour favoured by the Mannerists. The difference
between El Greco and Michelangelo in their approach
to religious subjects is well illustrated by El Greco's
judgment of the great Florentine painter's work in the

16 *Allegory of the Holy League* 1576–77

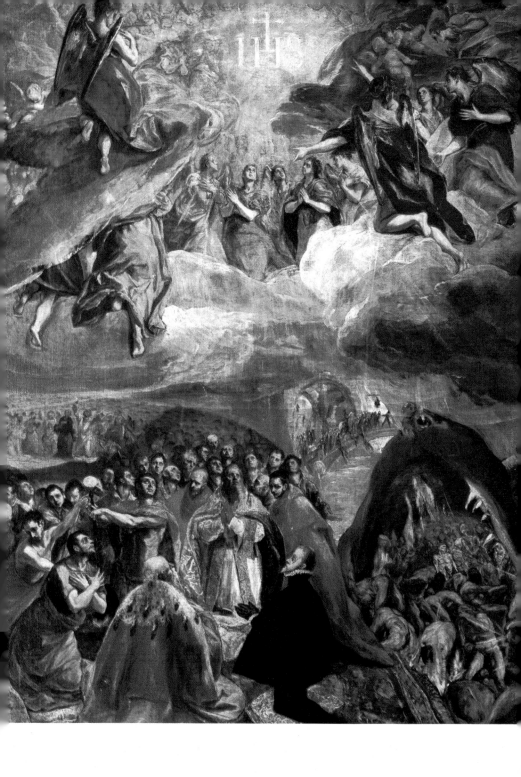

Sistine Chapel. It is unfortunate that El Greco was unable to express his great themes in frescoes, for he was particularly conscious of the limitations imposed on him by lack of space.

The few works of this period that can be attributed to him do nevertheless show a quite discernible Roman influence. El Greco abandoned the horizontal compositions he worked on in Venice and began to range his figures one above the other, mostly employing what Aznar calls a 'zenithal' construction, one which was popular with the Mannerists of the time. The figures are placed above each other in such a way as to channel interest towards the centre, so that the spectator's eye is focused upon a point rather than being led on towards the horizon. The corners of the picture are usually occupied by figures. The lower section of the canvas, reserved for the anecdotal characters, becomes a sort of popular *humus*, the earth which bears the weight of the whole of the bi-partite composition.

In, for example, a new version of the *Purification of the Temple*, El Greco abandoned his Venetian horizons and disposed his characters around the central group; his other paintings too reflect this different approach. In the earlier version, in the National Gallery, Washington, the Christ figure tends to look stranded in the middle of the canvas between the architectural structure and the vast expanse of the sky. But in the version dating from his Roman period, and in all the later versions, the monumentality of the architecture is toned down, the figures are concentrated into two compact groups, and the wrathful Christ is placed in

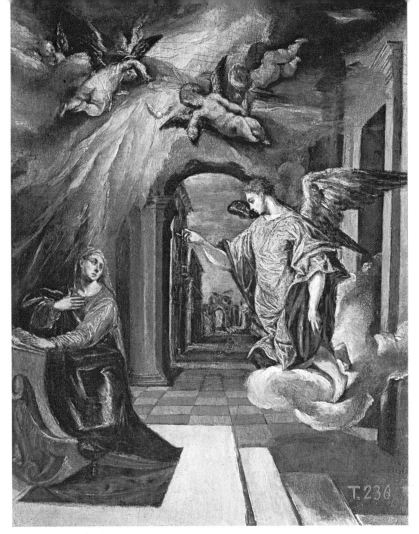

17 *Annunciation* 1575

the centre, indisputably the most important figure and the focus of interest.

The *Purification of the Temple* [18] of the Roman period, painted in *c.* 1572 and now in the Minneapolis Museum, is similar in composition to the Parma *Christ Healing the Blind*, even though it is of later date. By

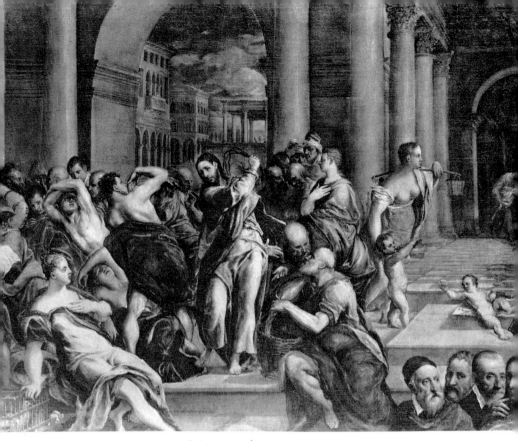

18 *Purification of the Temple c.* 1572

comparison with the painting in the Cook Collection,
the figures are much more robust and solid, and the
brushwork has lost something of its spontaneity and
verve. This increased pictorial density is accompanied
by a more subjective mode of expression and by some
of those arbitrary distortions of drawing that are so
characteristic of the painter's later works. The inspira-
tion is Titian rather than Tintoretto. The four figures
in the lower right-hand corner are taken to be portraits
of Titian, Michelangelo, Giulio Clovio and an

anonymous man who might be the artist himself, although others believe the model is Raphael.

Another picture of this period, the *Espolio* (*Disrobing of Christ*), is similarly organized, in typically Roman style, with all the interest centred on the Christ figure

19 *El Espolio (Disrobing of Christ)* 1572–75

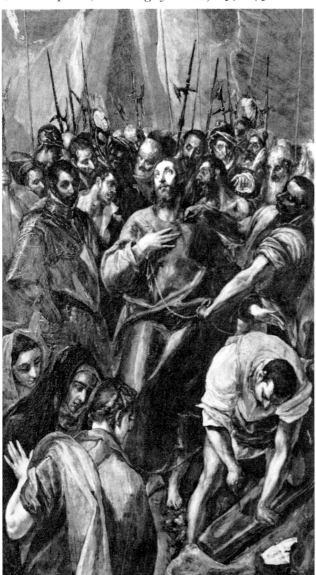

in the middle of the canvas. El Greco laid increasing stress on the vertical movement, the chief figure and those about him being caught up in the same soaring rhythm.

There are two versions of this *Espolio*, one in the Justi Collection in Berlin, the other formerly in the Contini-Bonacossi Collection in Florence [19]. Their style suggests that they precede El Greco's Toledan period, although Mayer places the second version in *c.* 1580. The evidence of the structural depth of the composition, the calm poses adopted by the figures, and the expanse of sky in the background, leads Camón Aznar to believe the painting belongs definitely to El Greco's Roman period.

The artist's taciturn and dreamy nature is revealed in a letter written by Giulio Clovio, which describes how he went to visit the painter in his studio on a sunny spring morning and found him seated in his chair, the curtains drawn, in almost total darkness. According to Clovio, El Greco refused to go out because, he said, the daylight disturbed his inner light. A further piece of evidence indicates a haughty and aggressive side to El Greco's character. From a manuscript by Giulio Cesare Mancini, doctor to Pope Urban VIII, we learn that the painter was asked to cover the nudity of certain figures in Michelangelo's *Last Judgment*, thought by the Pope to be indecent, and replied that it would be better to destroy the work entirely as he could do a new version 'with honour and decorum' that would be at least its equal. The manuscript goes on to say that other painters and art patrons were so incensed by this statement that El

Greco was obliged to depart for Spain. This is a demonstration of El Greco's pride and the consciousness of his own worth that he was to retain all his life. It reflects the isolation of the man of genius and can be justified, at least in part, by the paucity of great painters in the Rome of his day. As to the date of his departure, or his flight if Mancini's manuscript is to be believed, it is difficult to be at all specific, but it must have been somewhere between 1572 and 1576.

El Greco's attack on Michelangelo, whom he admired greatly as a sculptor, was really over a matter of principle. El Greco disputed the validity of this attempt by Michelangelo to represent celestial visions, like the magnificent scenes of the creation, in terms of this world, however grandiose the conception. He believed classical mythology was an inadequate vehicle to express religious sentiment and that it was a betrayal to embody holy themes in Antique forms.

In fact El Greco owes a considerable debt to Mannerism, both in terms of iconography, his general 'types' of holy personages becoming increasingly idealized and possessed of fewer individualized characteristics; and in terms of composition, the use of circular and oval formats with the power concentrated in a central core and the anecdotal and more realistic details relegated to the periphery. It appears El Greco found this organization of his canvas was better suited to express visions of the imagination or celestial scenes than the horizontal settings of Venetian art, always rather theatrical in style. A central upward movement could lift up the forms and free them from all contact with the earth: the robes become no more than vast planes

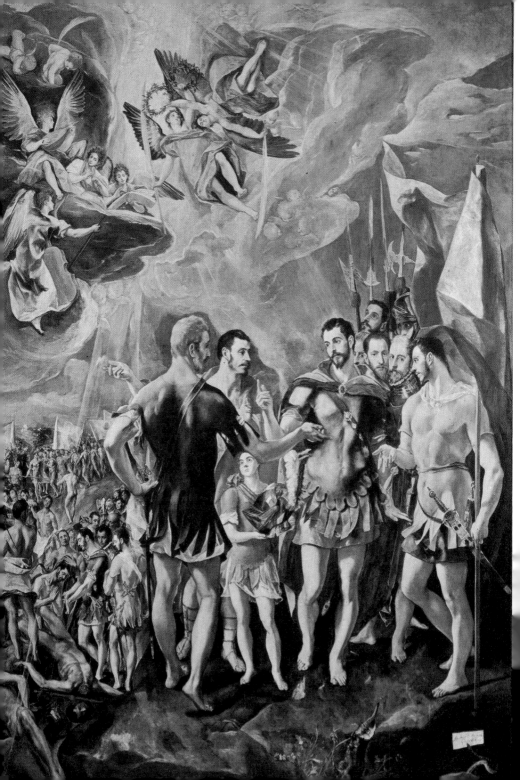

21 *Portrait of a Gentleman* 1584–94

of colour, obedient to rhythms that are unrelated to
weight or density, reflecting the essential nature of the
character.

While in Rome El Greco painted another version of
the *Boy Lighting a Candle* [14] (today in the Museo

20 *Martyrdom of St Maurice* 1580–82

Nazionale di Capodimonte, Naples), an instance of his use of clay or plaster figurines, which he made himself, to experiment with the contrasting effects of candle light, effects which exactly suited the ghostly and unearthly fulgurations of his brushwork. He followed the same procedure for the nocturnal scenes of the great compositions he painted later in his life.

Also in the Naples Museum is a portrait of *Giulio Clovio* [15], El Greco's friend and benefactor. It was painted in Rome in *c.* 1570, when Clovio was seventy-two, and shows the miniaturist as a man of splendidly noble bearing. The colouring and Titianesque technique are still typically Venetian. Giulio Clovio's friendship with El Greco influenced the painter's life in several important respects, as much in Rome, as it was to do later, in Toledo.

El Greco in Spain

El Greco's arrival in Spain remains one of the most obscure moments in his life. The date on which he entered the country is not known, nor are the reasons for his going there. Mancini's account explains why he left Rome but there is still a considerable gap between his departure and his reappearance in Toledo, and no documentary evidence has come to light to show why he chose Spain as his ultimate destination.

What he did in the interval remains a complete mystery. It has been suggested that he went straight to Madrid and assisted on some obscure decorations or architectural work at the Escorial. He may have broken his journey in Malta, where there are indications of his presence at some time. He received his first important commission in Toledo in 1577 (the paintings for Santo Domingo el Antiguo), and one can deduce from certain clauses in the contract that he had already established residence in Madrid and had work in progress. By this time he was living with Doña Jerónima de las Cuevas, the woman who remained with him for the rest of his life. He had brought with him a number of paintings done in Italy and was already regarded as an acknowledged master.

There can be little doubt that the *Allegory of the Holy League* [16] (later given the incorrect title *Dream of Philip II*) dates from this period. Its chromatism, the way the golden light is painted in abrupt strokes, its

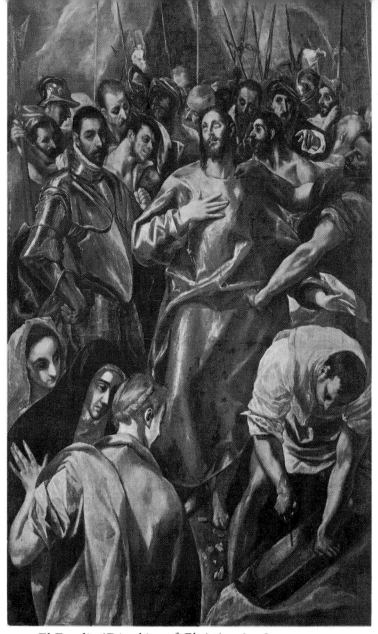

22 *El Espolio (Disrobing of Christ)* 1583–84

23 *A Holy King* 1585–90

incisive drawing and use of Venetian-style modelling, are all characteristic of a period of transition between Italy and Spain, and indicate that it was painted in 1576 or 1577. The theory that it was painted much later, on the occasion of the death of Philip II, seems impossible to sustain.

45

It would appear that El Greco wanted to combine in one work every possible proof of his compositional subtlety and astonishing technical skill. Taking his inspiration from St Paul, he represents heaven, earth and hell, all adoring the name of Jesus. The perspective is still fairly deep and the three worlds are sited unexpectedly in relation to each other: hell is adjacent to the earth, contained within the jaws of a monster. The figures are not distorted, although the background is only lightly sketched in. If the painting is indeed of the date suggested, and if it is some kind of test piece designed to show off El Greco's abilities after his time in Italy, that would lend weight to the widely held theory that the artist was hoping to work at the Escorial, knowing that Philip II had summoned some of the greatest artists to assist in its construction.

Michelangelo had been invited to submit designs for the tomb of Charles V. Titian, although he refused the King's invitation, painted a *Last Supper* for the refectory in 1564, and a *Martyrdom of St Lawrence* for the church in 1567. Barocci, Veronese and, in 1572, Vasari, were also asked to participate. It was only Vasari's advanced age that prevented him from making the journey. Painters who responded to the invitation included the most famous Roman artists of the age, Romulo Cincinato, Luca Cambiaso, Federico Zuccaro and Pellegrino Tibaldi, whose aesthetic viewpoint was far removed from the traditions of Spanish painting, still very provincial in character.

It is possible that El Greco learned of the invitations issued by Philip II through Juan de Verzosa, one of the most illustrious of the Spaniards living in Rome, and

24 *El Espolio (Disrobing of Christ)* 1577–79

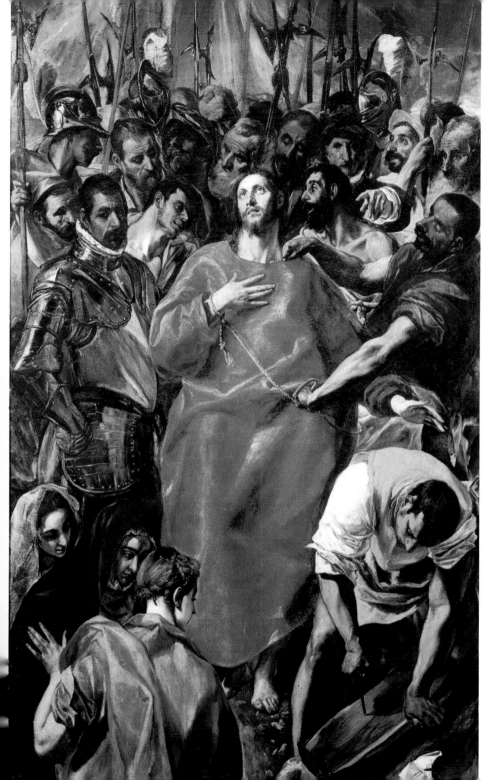

also the man charged by the Spanish King with the task of recruiting artists for the decorations of the Escorial. Giulio Clovio tried several times to obtain a commission for a *Saint Lawrence*.

Another possibility is that a Cretan copyist Nicolas de la Torre, then working in the Escorial, or another Greek from the monastery library, Andrea Darmario, may have encouraged their fellow countryman to join them in Spain.

In fact there could have been any number of reasons for El Greco's decision to go to Spain and one possibility does not exclude another. It may well be that he had been offered a commission to work in Toledo.

It is thought to have been his friend Fulvio Orsini, the librarian at the Farnese Palace and a great collector of medals and paintings, who first encouraged the artist to go to Spain and then obtained for him his first commissions in Toledo. This is far from impossible as Alessandro Farnese's library in Rome was the place where intellectuals and artists from all over Europe used to gather when they were in Rome, and Fulvio Orsini was in touch with several Spaniards, including a number of scholars from Toledo.

For instance Pedro Chacón and Luis de Castilla, who commissioned El Greco to paint the altarpiece for Santo Domingo, both lived in Rome and moved in these circles. Orsini also knew García de Loaysa, the canon from Toledo who, on 2 July 1577, signed a document granting El Greco an advance for the *Espolio*. Castilla and Loaysa would therefore have been the first Spaniards with whom El Greco had dealings and might easily have persuaded him to go to Spain.

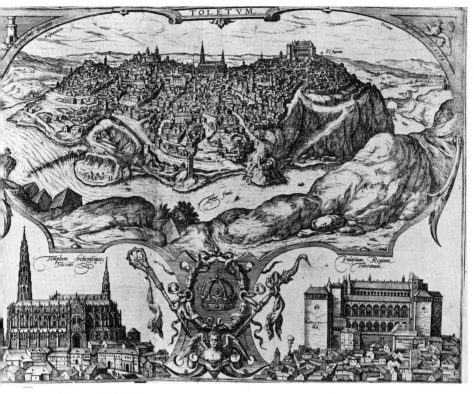

25　*View of Toledo* 1582

There is documentary evidence that would suggest that El Greco did not intend to stay in Toledo permanently. For example, in 1578 he declared that he would not leave the town until he had finished the paintings commissioned for Santo Domingo el Antiguo. It was probably the birth of a child, the admiration his work aroused, and the major commissions he received, that made him decide to stay. In August 1577, he

49

26, 27 Toledo: El Greco's House
View of the Garden. View of the Balcony

28 Toledo: Museo
del Greco

signed a statement that he owed money to the Dean of Toledo Cathedral 'on the occasion of my return to Madrid'. This would confirm the hypothesis that he spent some time in Madrid, possibly spending about a year there in 1576–77.

It therefore seems that he moved to Toledo in July 1577, remaining there until the end of his life. The only documents for the whole of this period are to do with commissions and the resultant lawsuits and litigation. It is possible to deduce from them something about his character, although by far the most revealing information is contained in his work, which alone can show his increasingly urgent and spiritual inspiration, his ever more bare and dematerialized technique.

The Toledans understood El Greco, they were unstinting in their admiration and soon expressed their pleasure by flooding him with commissions. He must also have grown to love the extraordinary city [25], the most exotic in Spain, built on a bare rock that may have reminded him of his homeland. He decided to stay. A traveller eager for new experiences, a wanderer who needed to be understood, he found what he was looking for in this austerely beautiful city perched high above the Tagus. For the remaining thirty-six highly prolific years of his life El Greco had found his rightful home.

In 1578 a son, Jorge Manuel, was born, later to be closely associated with the painter's work. His domestic life was happy, otherwise nothing is known about it.

There is a curious picture bearing the title *The Family of El Greco* [29], which can be interpreted in different ways depending on the date of its execution. The

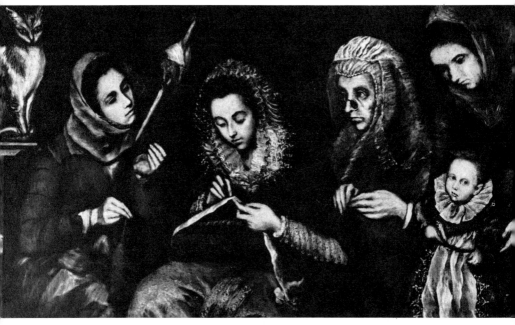

29 *The Family of El Greco* 1605?

question of El Greco's marriage to Doña Jerónima has never been satisfactorily resolved. In spite of Francisco Borja de San Román y Fernández, having searched the Toledan archives, there is no formal proof whatsoever of El Greco's marriage to the woman who has never been designated as anything other than the mother of his son. According to those who support the marriage theory, this would be quite uncharacteristic of that period in history and of that society in particular, especially for a painter receiving so many commissions from the Church. However this is the sole argument

that can be put forward in support of this claim, and it lacks a certain objective judgment about life in another age. Perhaps El Greco's situation was not all that unusual in a Spain that was controlled only with difficulty by the iron hand of Philip II and all the rigours of the Inquisition. At the time, people of many races, religions and traditions lived side by side, not yet reduced to the sober uniformity of later centuries. Muslim and Jewish social and religious practices were observed, even if they had to be carried on in secret. Mysteries and untoward occurrences must have been commonplace.

Until 1560 Toledo was the capital city of Spain, and it reached the height of its splendour in the second half of the sixteenth century. Historians estimate that the population must have fluctuated between 60,000 and 100,000 inhabitants. Moors and Jews flocked to make their home there, also Spaniards from other provinces, notably Galicia and Asturias, and there were in addition many foreigners, French for the most part but also Italians and Flemings. In a letter dated 1604, Lope de Vega wrote that 'Toledo is dear, but celebrated'.

Philip II and his court left Toledo in 1562 but, as Camón Aznar has rightly stressed (correcting the view held by Barrès that El Greco's work expressed all the unfathomable sadness of a city in decline), the city on the Tagus was still at the height of its prosperity at the time El Greco made his home there. Whether or not it was officially recognized as such, it was still the true capital, and its decline, which happened very suddenly, did not begin until the early years of the seventeenth century, at the time when El Greco was already an old

man and obsessed with his own personal researches, that were in any case doomed to be misunderstood. The departure of the court, which had never used Toledo as more than a base to return to in between its frequent peregrinations elsewhere, does not seem to have had much effect on the life of the town, one of the most heavily populated and richest in Europe. To find a place to live was a real problem for Toledo was the centre of a thriving trade in silk, wool, weaving, brocades, ceramics – the most prized Moorish tiles (*azulejos*) were produced in the small neighbouring town of Talavera – and in particular swords and damascene work, all of which trades won the town a world-wide reputation. It was the expulsion of the Moriscos by the command of Philip III, in 1609 and 1610, that brought many of these activities to a halt.

Toledo was, and indeed still is, the headquarters of the Church in Spain. For that reason it possessed fabulous treasures and contained an extraordinary number of churches, monasteries, religious colleges and foundations. The revenues accruing to the Chapter amounted to a larger sum than the combined income from all the other ecclesiastical sources in the rest of Spain and provided the town with an assured source of finance. The Archbishops were always great patrons of the arts.

While El Greco was living in Toledo, work was completed on the great Baroque Church of San Juan Bautista, the Hospital Tavera, the buildings of which were constructed on such a massive scale that, in his famous painting of Toledo, El Greco was obliged to place it in a different position so that it would not mask

the view of the town. The Cathedral gained two new additions, the Chapel of the Sagrario and the Mozarabic chapel in which Jorge Manuel did some work. New monasteries were built, and major construction work was undertaken at the Alcazar and the Ayuntamiento.

Toledo was above all the intellectual and spiritual capital, 'the glory of Spain, the light of the Arts . . . the Holy City' as it was described by Cervantes, who spent some time in the town and made it the setting for two of his *Novelas ejemplares*. It came under the influence of the greatest mystics of the age, St Theresa and St John of the Cross; the University, then at its peak, was the equal of Salamanca or Bologna, the two most renowned universities of the Catholic world, it had twenty-two chairs and theology was taught in several of the colleges; writers and scholars used to meet for learned discussions at the home of the Conde de Fuensanida or the Conde de Mora or in the country house of Cardinal Sandoval, the celebrated 'cigarral de Buenavista'.

Questions were disputed in an atmosphere of frank enquiry and freedom to pursue perfection and formal beauty, an atmosphere that must, in marked contrast to that created shortly afterwards under the Inquisition, have been very close to the mood of the Italian Renaissance. El Greco's closest friends were Fray Hortensio Félix de Paravicino, the famous preacher, and his colleagues, the great Cordovan poet Luis de Góngora, the distinguished Hellenist Antonio Covarrubias, portrayed in many of El Greco's works, the poet Ercilla, the explorer of Patagonia, Baltasar Gracián, the author of *El Discreto*, a description of a typical courtier. It is

curious that Lope de Vega, who lived in Toledo from 1603 to 1607 and used to make a point of mentioning in his works the artists he knew, should have omitted the name of El Greco. It may have been because artistically they were in total opposition, or because they moved in different circles, it may even have been due to the enmity that existed between Lope de Vega and Góngora, who was of course a great friend of El Greco.

In this intellectual society of fine and cultivated minds, the role of the women (the beautiful and proud women of Toledo who, according to Baltasar Gracián, could say everything in a single word) would have been one of discretion and modest charm. This must have been true of the relationship of Doña Jerónima with El Greco. It is generally assumed that she provided the inspiration for the face of his Madonnas, painted with unaccustomed tenderness and abandon, the most beautiful example being the Virgin in the *Holy Family* of the Hospital Tavera. This type of woman with wide pleading eyes, fine quivering nostrils and small full lips, offers an image of alert and gentle beauty that seems strangely young and alive in a world occupied by creatures of the spirit, no longer entirely of this world.

Together with El Greco and Doña Jerónima, their son Jorge Manuel and his wife Alfonsa de los Morales, lived the Manoussio Theotocopouli already referred to, a relative and possibly El Greco's brother. He was, of course, Greek and according to Jorge Manuel and Preboste was born in 1529 or 1530; he was entered in the town register as a 'resident' of Toledo. Francisco Preboste and María Gómez are referred to in several

documents as El Greco's servants, but in fact Preboste was more an assistant and enjoyed the painter's full confidence. Luis Tristán, the only Spanish disciple of El Greco who can be named with certainty, worked with the master between 1603 and 1607, possibly longer, and Preboste, Tristán and Jorge Manuel were almost certainly the artists responsible for the vast numbers of pictures attributed to El Greco. The highly organized studio used to produce several versions of the painter's favourite themes simply in order to keep pace with the demands of clients, who came from all parts of the province and even beyond. In 1597 Preboste was sent to Seville to collect money owed by an agent who sold paintings produced in the studio on a regular basis. The works in question were described as 'painted images, canvases and other things' in the document empowering the agent to collect the proceeds from sales made on behalf of El Greco and Preboste.

El Greco must have led two separate existences, a part of his life being jealously reserved for the pleasures of life with his family and close friends, tinged no doubt with nostalgia for his native country. There are many proofs of his affection for Greece, and this no doubt explains why he reverted to Byzantine forms in his late works. El Greco was always a difficult character, he never lost that pride and consciousness of his own worth that had forced him to leave Rome and which later made him engage in frequent legal wrangles with the Chapter of Toledo Cathedral. Manoussio, his supposed brother, appears in many portraits as a distinguished elderly man enveloped in furs. El Greco never failed to welcome those of his fellow countrymen who

came to beg for contributions to the ransom money necessary to free some relative captured by the Infidel.

Yet on the other hand there was El Greco the great artist and learned scholar, an illustrious and respected figure in spite of some reservations about the strangeness of his paintings. In religious circles at least, it did not take long to realize the magnitude of his achievement in translating into visual terms the purest form of mystical experience. People consulted him as an international authority on the most abstruse problems to do with the relationship between art and religion.

El Greco was a very learned man. Thanks to the precious inventory of his library that was drawn up at the time of his death, we are aware of the breadth of his interests, which ranged from the Greek tragedians and philosophers to the sciences and architecture; works that had only just been published abroad were already in his possession. He had in fact made a study of architecture and written a long treatise on the subject, but unfortunately this has disappeared.

In his library, Homer, Euripides, Demosthenes, Isocrates, Aristotle, Lucian and Aesop were side by side with the Bible and the works of the Fathers of the Church, all of which editions he possessed in Greek. In Italian, he had not only the works of Tasso, Petrarch and Ariosto, but also two learned theses on medicine, writings on architecture by Vitruvius, Palladio, Alberti and Vignola, and various accounts of Ancient Rome. He had read the contemporary works of Botero and of Francisco Patrizzi, who thought the philosophy of Aristotle was incompatible with Christianity, and that light was the synthesis and ultimate expression of the

divinity. At his meeting with Pachecho El Greco expressed similar views.

The many houses [26, 27] occupied by El Greco at various times have not all been identified, even though the plan of the town has remained the same over three centuries. We do know that he lived for the longest period in premises that had once formed part of the palace of Samuel Levi, Pedro the Cruel's notorious Jewish banker, who was assassinated by the King for his money. In 1585 the artist rented for a substantial sum a number of rooms adjoining the main wing of the palace. He left there in 1589 and moved to a house owned by Juan Suárez of Toledo, but returned for good in 1604. He occupied twenty-four rooms and the adjacent gardens, patios and courtyards. This was during the period of his greatest prosperity, when his way of life was regarded as extravagant and affected. El Greco had learned to love Italian luxury; he was temperamental, ostentatious, generous and lacking in foresight. Comments made by Pachecho, Jusepe Martínez and Palomino enable us to glimpse the harshness of certain people's reactions to this proud and sophisticated man, who spent the money he earned on hiring musicians so that he could experience 'all manner of delights while he dined'. This spiteful and shocked reaction of Jusepe Martínez confirms El Greco's love of music, which is apparent in many of his works.

There can be little doubt that El Greco was more interested in beautiful, rare, *objets d'art* than his own comfort. We know he had dealings with goldsmiths and embroiderers. But at the time of his death, on 7 April 1614, the inventory of his possessions reveals a

59

genuine poverty. It is clear that for some years his business affairs had been in a poor state, the last reference to the diligent Preboste occurs in 1607. The painter apparently became an invalid, unable to accompany Pachecho to his studio. He became obsessed with matters of purely personal artistic research, experimenting with forms and materials, and did not care whether there were clients for his work. As the crisis overtook Toledo, the city shrank back upon itself. Deserted by the poets and the people who contributed to its wealth, it took on a new melancholy aspect. Jorge Manuel kept his father's house in repair, effecting some improvements, but the ill-assorted crumbling Gothic structure cannot have lasted long. The modern museum of the house of El Greco is only a reconstruction, although it is a faithful copy of what the artist's house must have looked like. Its site is almost exactly where the original house stood, and you can look out from the windows and terraces across the Tagus and see the view El Greco once saw.

El Greco died on 7 April 1614, after a long period of illness. He was buried in Santo Domingo el Antiguo in a vault reserved by Jorge Manuel in 1612; the chapel contained the *Adoration of the Shepherds* El Greco had painted expressly for this purpose. But in 1618, after a quarrel with the Abbess and nuns of Santo Domingo over the non-completion of works promised in payment for the vault, Jorge Manuel was obliged to transfer his father's body to the church of the Monastery of San Torcuato, where he had a vault specially constructed. As the Monastery no longer stands, nothing is left of El Greco's remains.

First Period: 1576–79

The El Greco of the first Toledan period is a magnificent painter. He still harks back to the warm tones and modelled forms of his Venetian days, the harmonious compositions that he transformed by his vision into vast planes of colour, forms in space, viewed from above or below, their rounded surfaces caught by unexpected rays of light. The monumental retable for Santo Domingo el Antiguo, no longer complete, is like a synthesis of all that was new in the painting of his century.

The large, untroubled figures of the *Resurrection* are reminiscent of Titian. Distortions creep into the *Adoration of the Shepherds* in response to the contrasts of light and darkness. The saints have the proportions of Baroque sculpture. The Prado *Trinity* [31] is the most typical of this period. The forms stand out in powerful relief, reminiscent of the work of Michelangelo, but they are, nonetheless, not of this world, they are swept up in a symbolic use of colour that is the reverse of naturalistic. White, the symbol of divinity, is the dominant colour of the sky; yellow represents the intuition of God, the source of all light. This work marked the appearance in Spain of all the best elements of Italian art combined in one grand new style. It caused a sensation and immediately established El Greco as one of the best painters of the time. One cannot stress too much the importance of this great work, destined for a building

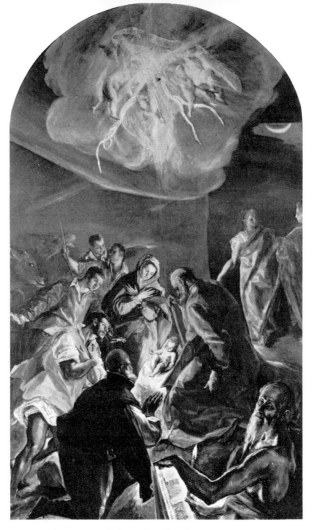

30 *Adoration of the Shepherds* 1577–79

with which El Greco had been closely associated right
from the start.

A document dated 16 August 1577 contains the
instructions to the master craftsmen to proceed with the
construction of the Church of Santo Domingo el

Antiguo, according to plans drawn up by Herrera, the architect of the Escorial; and on 11 September of the same year Monegro was commissioned to carve the retable for the Church according to designs by 'Mecer Domenico Theotocopouli', a fact which confirms that El Greco's reputation preceded him to Toledo. The *Assumption* [33] occupied the central panel of the High Altar (later replaced with a mediocre copy; the original

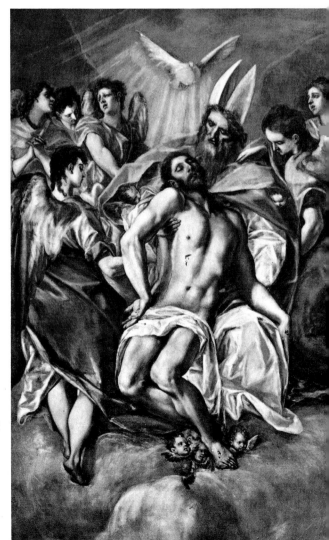

31 *Trinity* 1577–79

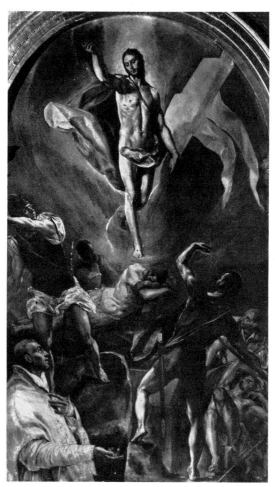

32 *Resurrection* 1577–79

is now in the Art Institute of Chicago). The theme is
that of Titian's *Assumption* in the Church of the Frari
in Venice, although there are considerable differences
between the two works. Titian's painting depicts the
characters in all their calm and unchanging beauty,
while the version by El Greco is striking for its quality

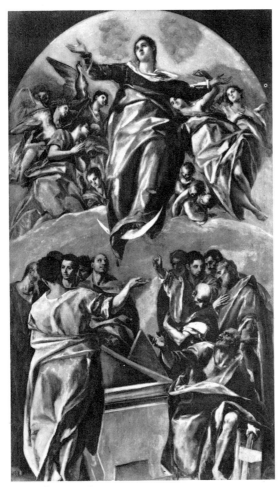

33 *Assumption* 1577–79

of evanescence, its volatile dynamism. In the Titian the apostles contemplate the ascension, in the El Greco they are staring at the empty sepulchre. The figure of the Virgin rising to heaven anticipates the iconographical type he used for the *Assumption (Immaculate Conception)* of San Vicente of Toledo; it is the first example of the

65

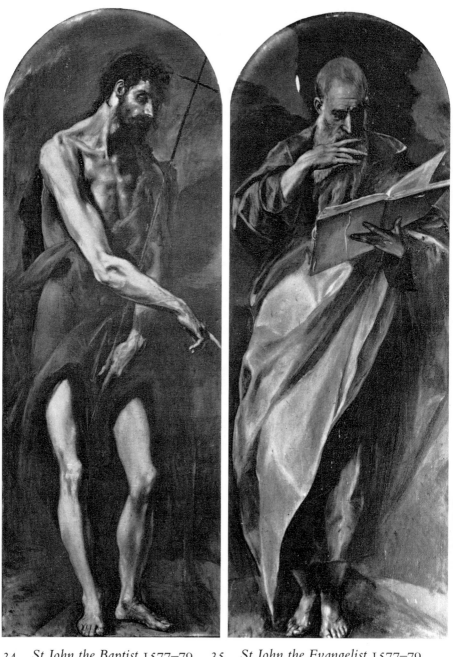

34 *St John the Baptist* 1577–79 35 *St John the Evangelist* 1577–79

use of a particular formal mechanism designed to make the figure appear to rise giddily upwards. The effect is not obtained by conventional methods, of distancing the object or blurring its forms, instead the large figure is placed squarely in the foreground and dwindles away almost to a point at the top, as though flying upwards. It is not, as Cossío supposes, that El Greco is evolving towards a more successful and life-like representation of reality, on the contrary, he is moving towards an impassioned, wilful and frenetic escape from that reality. The work is signed and, unusually for El Greco, is also dated, 1577. It is certain that the other sections of the altarpiece are of later date as, in a document dated 27 July 1578, El Greco announces that the paintings are still not finished and that the ongoing work on the construction of the Church would in any case have prevented him from having them displayed.

The *Trinity* [31] is a very fine work. It was probably inspired by Taddeo Zuccaro's *Dead Christ Surrounded by Angels Bearing Torches*, in the Villa Albini, and the picture of the same title in the Borghese Palace. El Greco would probably have seen Dürer's engraving of 1511, and may have been influenced by certain of Michelangelo's *Descents from the Cross*, notably the 1553 version in Palestrina and more especially the version in Florence Cathedral, which dates from 1550–53. The originality of El Greco's contribution lies in the way he juxtaposes abstract forms with figures of such realism that they serve to enhance the supernatural aspects of the picture.

St John the Baptist [34] and *St John the Evangelist* [35] occupy two vertical panels, the latter is of a grandeur

rarely attained by El Greco. Even though strongly influenced by Roman iconography and by Michelangelo, it nevertheless bears no trace of Mannerist excess. The *St John the Baptist* equals its companion panel in nobility and power, but it lacks the Roman influence. Here the character is a realistically drawn mystic, his expression calm yet piercing, a man taken from the world in which the artist lived, with not a trace of Italian classicism.

The *St Benedict* is today in the Prado; its technique makes it doubtful that it was contemporary with the other works commissioned for Santo Domingo. The *St Bernard*, the original of which is now in the Chéramy Collection in Paris, is expressive of the wisdom and humanism of certain of the Spanish mystics. The gentle and meditative beauty of the face is its most striking feature.

On the pediment of the altar, set in an oval frame supported by angels, is the *Veronica (Santa Faz)* [36]. It is of Byzantine inspiration and is the first example of an expression on the face of Christ which El Greco was to return to on many occasions; it is a look of calm serenity, expressing none of the conventional agony, not a hint of pain, fatigue or bitterness. Cossío sees in this work a direct debt to Dürer, who was, in his opinion, one of El Greco's chief sources of inspiration.

The *Adoration of the Shepherds* [30], on the lateral altar on the north side, is a subject which never lost its appeal for El Greco. Influenced by Bassano and by the version of Correggio's *Night* now in Dresden, it is a supremely controlled treatment of the candle-light effects he had first employed in the Venetian and Roman versions of

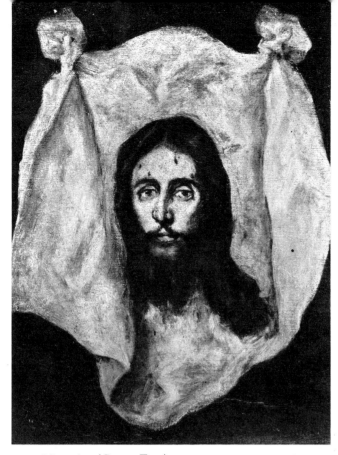

36 *Veronica (Santa Faz)* 1577–79

the *Boy Lighting a Candle* and to which he was to return frequently in later paintings. Here the light spills out from the Christ Child in the centre, illuminating the characters in the shadows about him so that their silhouettes are sharply accentuated. The figures are organized in such a way that they seem to float in the adjacent spaces, allowing their gestures to be full and unconfined. This compositional technique, anticipating El Greco's later treatment of space, replaces con-

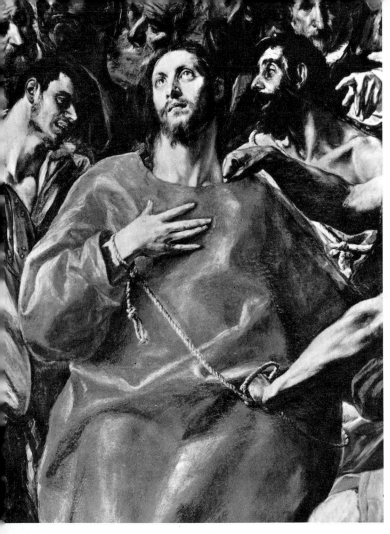

37　*El Espolio* Detail

struction in depth: the figures are superimposed without their dimensions being in any way modified by an effect of perspective. Later even the background was incorporated into the two-dimensional plane, and the composition was conceived entirely in vertical terms.

The *Resurrection* [32], on the lateral altar on the south side, repeats Venetian and Roman motifs. Once again there is an echo of a Dürer engraving, the sleeping soldier hunched up on the right of the picture. The way the composition is divided into two parts completely alters the traditional iconography, according to which Christ is shown beside the sepulchre. Here he is represented already in Heaven, glorious and triumphant. Cossío believes the benefactor in the left-hand corner is Don Diego de Castilla, the Dean of Toledo Cathedral, the man responsible for the building of the Church.

The works for the altars of Santo Domingo were of supreme importance for Spanish art and marked the

38 *El Espolio (Disrobing of Christ)* 1577–79

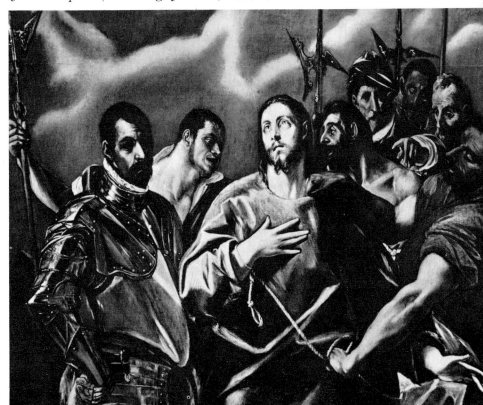

beginning of a new phase of El Greco's development as an artist. They introduced the art of sixteenth-century Rome to Spain at a time when Spanish painting was still largely under the Gothic influence. In a period when Europe was experiencing a great stylistic unity, the altarpiece constituted the first great ensemble linking Spanish painting with the aesthetic principles derived from the Council of Trent.

The grandiose conception of the figures raises certain problems. It may be that El Greco worked on the theme in a studio in Rome even before he went to Spain, but this is mere conjecture. It is however salutary to recognize the dangers of assuming in a simplistic fashion that, with every picture he painted, El Greco progressed steadily towards more spiritualized, more Baroque forms, rendered with ever looser brushwork. Clearly in this altarpiece he reverted at times to Roman forms, even though he did not abandon the experiments that laid the foundations for his magnificent later works.

Contemporary with this panel is the *Espolio (Disrobing of Christ)* [24] for the High Altar of Toledo Cathedral, where it can still be seen and admired. It represents one of the climaxes in the painter's career. It is likely that the Cathedral Chapter waited to see the completed *Assumption* in Santo Domingo before giving this commission. The dates tally, as the Santo Domingo retable is of 1577, the year the *Espolio* was commissioned; the exact date is probably 2 July as this was when El Greco received the customary first advance, of forty-four reales.

The *Espolio* represents Christ being taunted before he is stripped of his tunic. But the absence of crown and

39　*El Espolio* Detail

40　*El Espolio* Detail

flagellation marks suggest that El Greco may have based his picture on a passage from the Gospel according to St Matthew, which describes Christ being stripped of his raiment by the soldiers and clothed in a scarlet robe. Or he may have been thinking of the Book of Nicodemus in the Apocrypha, where it is said that, when Jesus reached Calvary, he was stripped by soldiers, who then placed on his head a crown of thorns and gave him a reed to hold before crucifying him.

Here for the first time El Greco demonstrates a striking originality, an intensity of expression and sense of

41 *El Espolio (Disrobing of Christ)* 1581–86

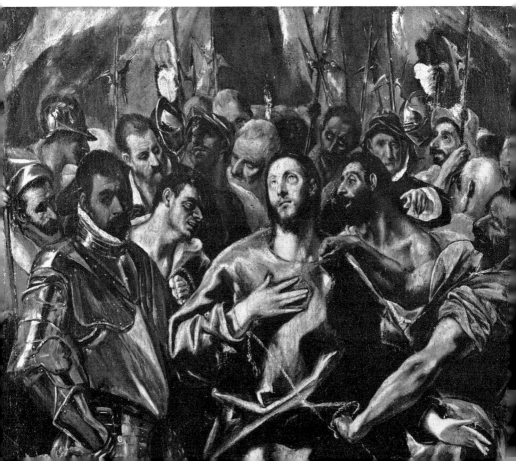

42 *Christ on the Cross c.* 1580

colour that are entirely without precedent. No hint
here of Venetian perspectives with vast horizons, por-
ticos and cloud-studded skies, nothing of the atmos-
phere of calm that used to pervade any scene, no matter
what the theme. All the laws of composition are thrust
aside in order to comply with the demands of the sub-

43 *St Francis Receiving the Stigmata c.* 1580

44 *St Francis in Ecstasy* 1577–80

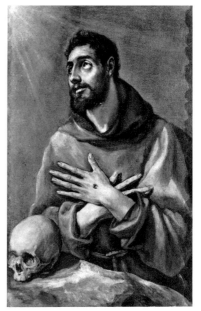

ject matter. There is no use of perspective, instead the figures are clustered about the Christ figure, yet the passion and hatred that is unleashed around him do not touch the lonely, mourning face [37] that is set back from the huge red expanse of the tunic. Only the groups on the left and right, the Holy Women and the astounding figure of the carpenter getting on with his work,

stand out from the flat surface, forming two powerful masses of relief in the foreground. There are certain details, like the foreshortening of some of the profiles and the effects of light on the helmets, of such technical boldness that they anticipate Velasquez. There is no mention in the Gospels of the Holy Women being present on this occasion, and this was one of the arguments put forward in the lawsuit brought against El Greco, in 1579, over the payment for the *Espolio*.

The composition is almost without depth and all the action seems to take place in the foreground. Here the artist is beginning to experiment with a pictorial organization that depends on filling all the surfaces, reminiscent in its density of Byzantine mosaics. Yet Byzantine painting, especially in mosaics, is rooted in the harmony and symmetry of the chromatic masses and reflected gleams of light. The faces are stereotyped and lack individualized characteristics or personal emotions. But the faces in the *Espolio* express many contrasting passions, and it is in this respect above all that El Greco's aesthetic approach differs from the Byzantine style.

The theme was one he had already treated in Italy, and it is possible that it was because the humanist canon of Toledo, García de Loaysa, was acquainted with the earlier work that El Greco was given the commission for Toledo Cathedral. There are something like fifteen other versions of the same theme by El Greco, the finest examples being in the Institute of Arts, Minneapolis, the Barnes Foundation in Merion, and in the Alte Pinakothek, Munich. In still other versions, now in collections in Majorca, Budapest and the Musée des Beaux-Arts, Lyon, the Holy Women and the slave are

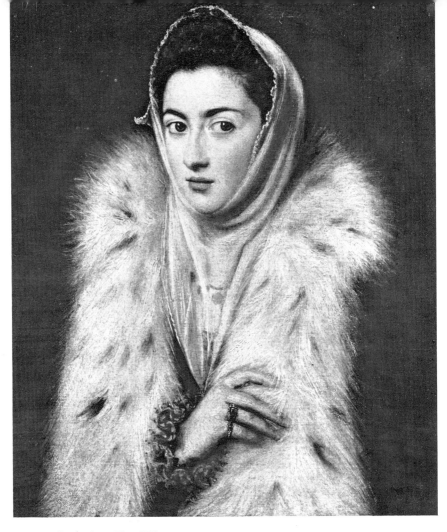

45 *Lady in a Fur Wrap* 1577–78

omitted, so that the composition is horizontal.

Other works of this period that deserve to be singled out include *St Francis Receiving the Stigmata* of the Zuloaga Museum Zumaya, in the Basque country, and *St Francis in Ecstasy* [44] in the Museo Lázaro Galdiano,

Madrid; the *Entombment*, in the Royal Palace in Madrid until it disappeared in the Civil War; the *Pietà* (*Lamentation*) of the Hispanic Society, New York; *St John and the Holy Women* in the Museo Lázaro Galdiano, Madrid; the *Annunciation* in the Prado; *Christ on the Cross* in the Del Valle Collection, Madrid; *St Lawrence's Vision of the Virgin* in the Monforte College; and the *Crucifixion* in a private collection in Madrid. There are also a number of portraits, among them *Lady in a Fur Wrap* [45] of the Stirling Maxwell Collection, Glasgow, of particular interest because it has been taken as the portrait of Doña Jerónima de las Cuevas.

The two small panels of *St Francis Receiving the Stigmata* mark the Saint's first appearance in El Greco's

46 *Christ in the House of Mary and Martha c.* 1580

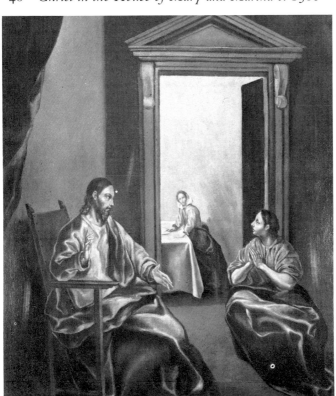

79

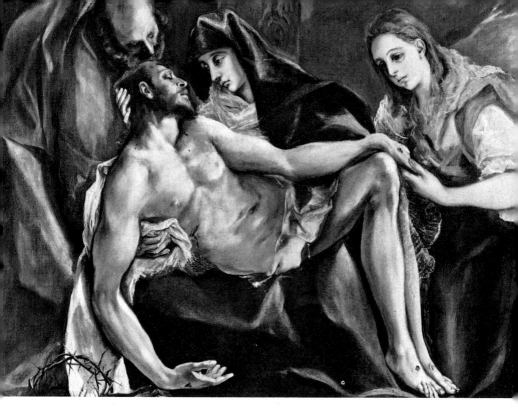

47 *Pietà (Lamentation)* 1578–85

work; Aznar has calculated that he is represented more than 120 times in all. St Francis, as well as the Virgin Mary was greatly revered in Crete, and was worshipped by Greek Orthodox and Catholics alike. Against a landscape of brilliant crystalline colours, that have the quality of enamel, St Francis is depicted, in accordance with traditional iconography, as a humble, human figure, although even here he is imbued with a certain pathos and mysticism. The first panel is signed and may date from El Greco's Roman period, although some place it during his time in Venice, and Cossío believes it was painted in Spain.

Second Period: 1580–85

What Aznar dubbed El Greco's 'St Maurice period' was a time of intense creative activity in the artist's life, in the course of which he produced many pictures on religious themes and won great popular favour. These works reflect an increasing preoccupation with sculptural forms, especially in the pronounced modelling of the foreground figures, and are pervaded with an atmosphere of intense calm and religious feeling, quite distinct from the turmoil and distortion of the late compositions. To this period belong the most popular devotional images, themes he returned to again and again and which are regarded as typical examples of his iconography. In particular, there are the new types of *St Francis*, the *St Sebastian* of Palencia Cathedral, the Prado *St Anthony of Padua*, the series of *St Mary Magdalen*, *St Catherine* and *St Veronica*, and the first *Crucifixions*. Among the portraits the *Portrait of a Nobleman with Hand on Breast* and the *Portrait of a Knight of St James* deserve to be mentioned.

In many versions of *St Francis* dating from this period, the Saint is shown as a young man, either clean-shaven or with a light beard. He is receiving the stigmata, standing and leaning slightly forward, his arms spread wide apart. In front of him is a skull, and Christ appears in the cloud-filled sky above the entrance to the cave.

In a second series, St Francis again appears as a young man, standing and praying in front of a crucifix resting

48 *St Anthony of Padua* 1580–85

on a rock; to one side is a skull and the background consists of rock, a patch of sky visible in one corner. His left arm is extended and his right arm is placed against his breast in a gesture often seen in El Greco's work. The hand, with the second and third fingers closed up, is typically Byzantine.

The third type [59, 60], probably the most familiar and one El Greco used frequently, shows St Francis with an emaciated face, kneeling in ecstasy before a

crucifix that is propped up on a rock or a table next to a book and a skull, set at an angle. His half-open cowl reveals his crossed arms, hands resting against his breast. The background is formed by the cave itself, and the light that illuminates the Saint spills out from one corner.

We come now to the great work of this period, the *Martyrdom of St Maurice* [20]. Commissioned by Philip II for the Escorial in 1580, it did not find favour with the King; this must have been one of the bitterest disappointments in El Greco's life. Although painted not long after the *Espolio*, this huge canvas is totally different in its spatial organization and in the contrasting perspectives used to represent the human figures and the angels. The conception of the theme is Italian, and was probably suggested to the painter by other decorations in the Escorial. Possibly some elements of the composition were dictated to the painter, as there are several points of similarity with the mediocre picture by Romulo Cincinato with which it was replaced. It is a 'holy conversation piece' in the Italian manner: the scenes in the background are treated independently of the main motif; the huge sky is thronged with archangels; there is a feeling of space which permits the characters to make expansive gestures, their expressive attitudes reminiscent of Mannerist sculptures; St Maurice, in particular, resembles Leoni's statue of *Charles V Dominating the Fury*.

This dialectical concept, of militant sainthood, is characteristic of many of El Greco's works. He conveys the mental processes of the saints, not in scenes of martyrdom or superhuman feats, but in actions that

reveal their spiritual intensity, outward manifestations of the inner tensions of thc vocation. It is not the Saint's actual martyrdom that is portrayed but his joy in anticipation of divine wisdom. The actual scene depicted is the moment of St Maurice's refusal to kill in order to save his life. Possibly it was the absence of dramatic content that made Philip II reject the painting. He may have found it impossible to accept a picture of the martyrdom of a saint that did not show the actual scene of martyrdom. Or his classical temperament may have been offended by the cold, shrill colours, the

49 *St Mary Magdalen in Penitence* 1580

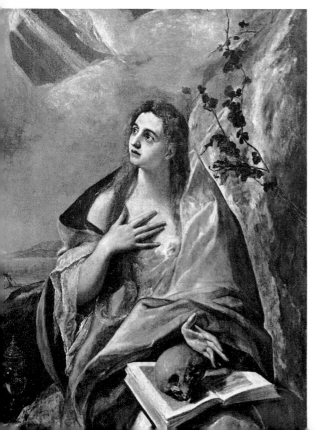

50 *St Catherine of Alexandria c.* 1610

51 *St Mary Magdalen in Penitence* 1580–85

52 *St Mary Magdalen in Penitence* 1580–85

53 *St Catherine of Alexandria* 1580–85

54 *St Veronica* 1580

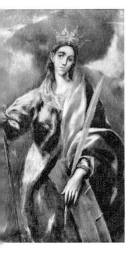

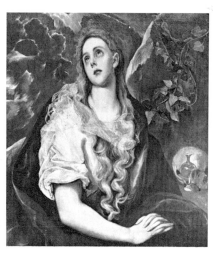

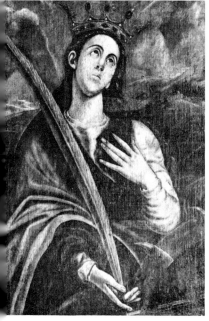

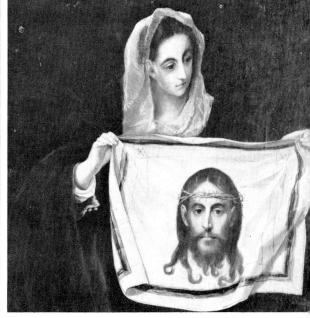

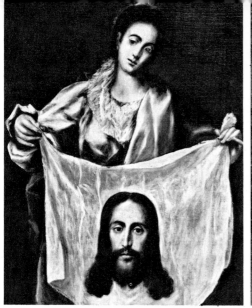 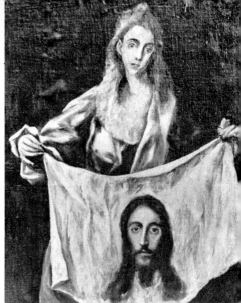

55 *St Veronica* 1580–85 56 *St Veronica* 1580–85

ghastly pallor of the light, the contrasts between the acid yellows and the predominant reds and blues, so very different from the golden warmth of a Titian. Presumably El Greco deliberately went against tradition when instead of representing the execution of St Maurice he showed him persuading his comrades of the Theban Legion to sacrifice their lives. Only in the lower left-hand corner of the canvas does he show a beheaded martyr, far removed from the central group.

The picture's most striking feature is its diversity of planes and perspectives. The characters in the foreground are viewed from below, while aerial perspective is used for the two groups in the distance and for the background. The angels who occupy the celestial zone, playing musical instruments or bearing crowns,

have Italianate forms with effects of foreshortening that are reminiscent of Tintoretto.

If El Greco had come to Spain in search of royal favour and patronage, he must have experienced bitter disappointment at his failure to please the King with his work for the Escorial.

The *St Sebastian* of Palencia Cathedral comes near the end of this period. Although it seems to be inspired by Tintoretto, its treatment corresponds closely to the manner of El Greco's first Spanish works. The Saint appears indifferent to the agony of his martyrdom and the design is still classical, but the ghostly light in the background has the effect of toning down the exaggerated modelling of the figure. The Prado *St Anthony of Padua* has a similar grey colouring; it is a true devotional image, full of gentle simplicity and grace.

El Greco had already painted a *St Mary Magdalen* in Italy, probably inspired by Titian. Like St Francis, she is represented in his work by three distinct iconographical types, reflecting the development of El Greco's style. The first type shows her seated in a cave, with a strand of ivy, a skull and a vase on an adjacent rock; her neck is long and slender, her eyes set in a glance of ecstasy. The finest example of this type is in the Art Museum, Worcester, Massachusetts.

The *St Mary Magdalen in Penitence* [49] in the Szépmüvészeti Múzeum, Budapest, is a good illustration of the second type, probably the earliest version. Her right hand is resting lightly on her breast, while the left hand is extended towards the skull and book in front of her. The face expresses ecstasy and love, the rounded features are reminiscent of Venetian women.

The third type, as in the version in the Musée Cau Ferrat, Sitges, is a more ascetic Magdalen with a drawn face and long, expressive hands, possibly the most beautiful ever painted by El Greco. The Saint is praying in front of a crucifix resting on a rock.

St Veronica [54, 55, 56] borrows directly from the *Espolio*, showing Christ's face on the shroud; the features are heavily modelled and life-like, in contrast with the pallid and insubstantial Saint who holds it in her hands. The finest known example is in the Caturla Collection, Madrid [54]. It is signed and comes originally from Santo Domingo. 1580 has been suggested as its likely date.

The *Appearance of the Resurrected Christ to the Virgin* is based on an apocryphal story in the Golden Legend, held in great reverence in the Middle Ages and later

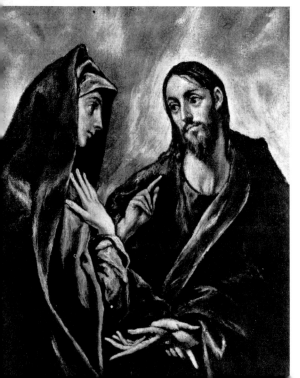

57 *Appearance of the Resurrected Christ to the Virgin* 1580–85

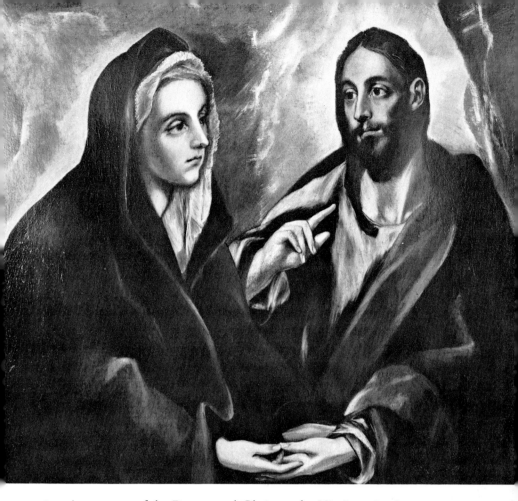

58　*Appearance of the Resurrected Christ to the Virgin* 1580–85

suggested as a spiritual exercise by St Ignatius. El Greco portrays the two characters in attitudes of calm, the Virgin Mary holding the hand of Jesus. There is no landscape to distract attention from the beauty of the faces and hands. The colouring is restrained, the red of Christ's tunic standing out against the blue cloaks. An

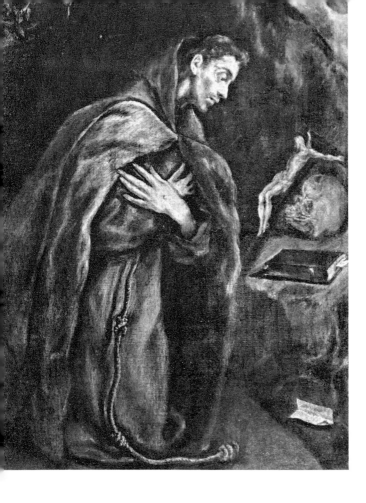

59 *St Francis in Meditation* 1585–90

alternative title for this picture is *Christ Saying Farewell to his Mother*, but there is no documentary evidence in its favour and no other representation of this theme.

Third Period: 1585–95

The most representative works of this period are the *Burial of the Count of Orgaz*; the *Deposition*; a few versions of *St Francis*, some similar to those of the previous period, others of a new type; several versions of *Christ on the Cross* and *St James the Greater*; also a few portraits and the major series of paintings of the saints.

These years marked the height of El Greco's achievement, poised between the Italianate period of his youth and the rapturous excess of his later work. His art moved away from the Mannerist influence and became a highly personal mode of expression, although it was still grounded in reality. Technically El Greco was at his peak. He applied the canons of Realism to the representation of spiritual values, and also began to introduce the distortions and elongated limbs that dominated his later works. Yet in these canvases he still wished to portray certain human types characteristic of his age.

The *Burial of the Count of Orgaz* [66] was painted in 1586 and was commissioned by Andrés Núñez, the parish priest of the Church of Santo Tomé, who had brought to a successful conclusion a long legal battle with the Count's descendants. The Count of Orgaz, who died in 1312, had made a will leaving an annual endowment to the parish where it was his wish to be buried. But, according to documents published by San

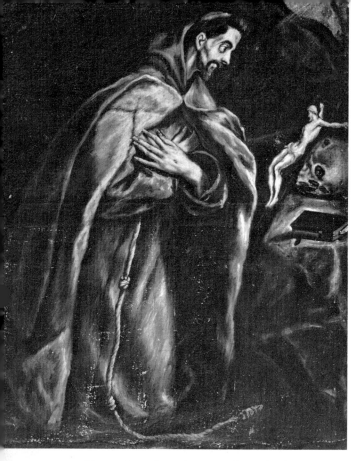

60　*St Francis in Meditation*
1585–95

Román, the Orgaz family had allowed the payments to lapse for two years and the parish priest brought a lawsuit against them. He won his case in 1570 and, on 18 March 1586, commissioned from El Greco a painting to commemorate these events. The Latin inscription beside the picture refers to the legend that, while the priests were preparing to bury Don Gonzálo Ruíz de Toledo, the Count of Orgaz, 'St Stephen and St Augustine descended from heaven and placed him in his tomb with their own hands'. The inscription continues: 'As it would take too long to explain the

Saints' motives for doing this, ask the Augustan brothers, if you have time.' In fact their motives are easily explained: the Count of Orgaz was responsible for the better living conditions enjoyed by the monks of the Augustinian Order, having made over a large amount of property to them, and he had asked that the new church he had had built should be dedicated to St Stephen. Hence the gratitude of the two Saints, who vanished, as soon as they had buried the Count, 'leaving the church full of heavenly perfumes and odours'. The specification for the picture stipulated that a large number of spectators should be shown watching the burial, and that the composition should be crowned by a Glory displayed in the sky.

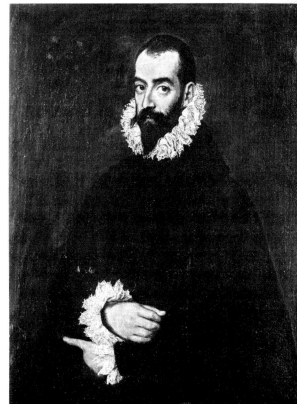

61 *Duke of Benavente* 1585

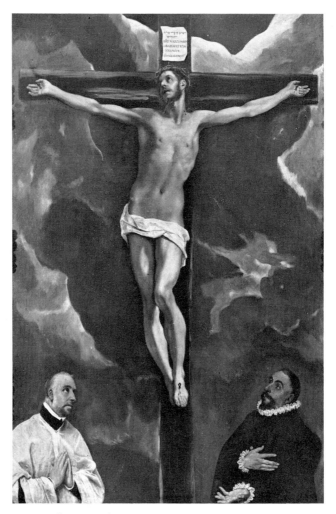

62 *Christ on the Cross* 1585–90

El Greco divided his canvas into two contiguous
zones, heaven and earth. In the lower section are St
Stephen [72] and St Augustine [67], holding the Count
by his feet and head before placing him in his tomb. In
front of St Stephen, kneeling with one knee on the

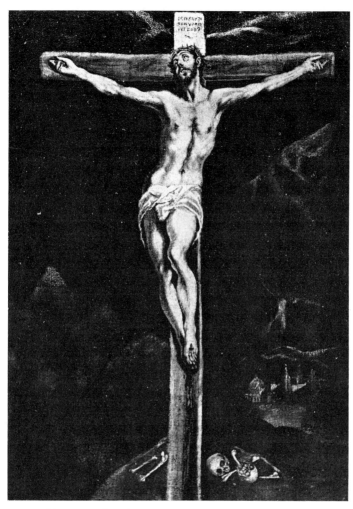

63 *Christ on the Cross* 1585–95

ground, is a child dressed in black [73]. He holds a long torch in his right hand, and points with the other hand to an emblem on the sleeve of the Saint's chasuble. Protruding from his pocket is a white handkerchief bearing the artist's signature and a date: 1578. This may

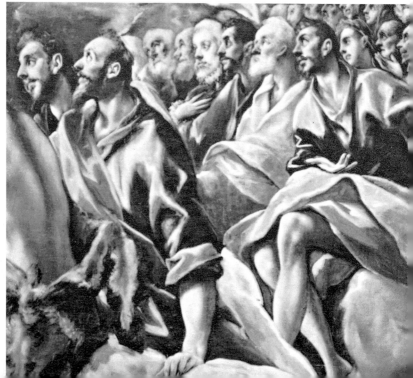

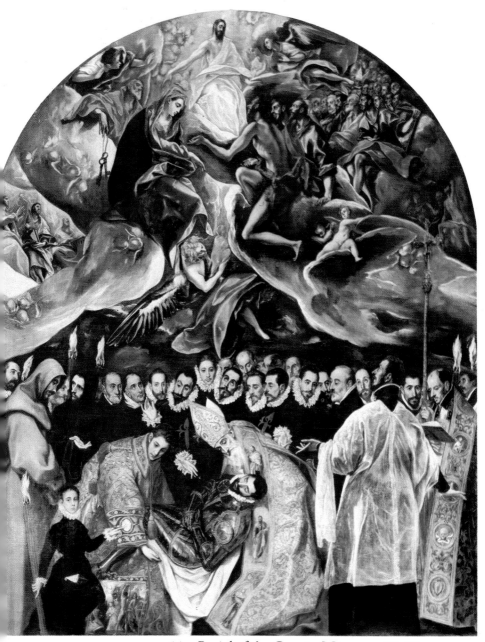

66 *Burial of the Count of Orgaz* 1586–88

65 *Burial of the Count of Orgaz* Details

be a portrait of the artist's son Jorge Manuel. The central characters are surrounded by the priests, monks [71] and noblemen attending the funeral. The Glory in the upper section shows Jesus in a white shroud, spreading wide his arms to welcome the dead man. At his feet, St John the Baptist [64] presents to him the Count's soul; it is in the form of a child, looking almost like a chrysalis, and is held by an angel who is hovering over the scene of the earthly funeral. Opposite St John the Baptist is the Virgin Mary, her attitude one of welcome and meekness. All around is a throng of angels and saints [65], among them a portrait of Philip II. Attempts have been made to identify other contemporary figures among the characters represented, especially among the *hidalgos* [70] in the lower section. The manuscript in which Francisco de Pisa describes the miracle refers to 'the presence of five hundred witnesses', and it is more than likely that El Greco would have chosen to portray men he knew. Yet the fact remains that, on the evidence of other portraits, the identity of only one of the nobles can be ascertained with certainty, Don Antonio de Covarrubias. Other attributions that have been made are based on pure conjecture.

The composition is modelled on the classical frontispiece. The parish priest of Santo Tomé and the Franciscan monk [69] stand like two columns framing the cortège of gentlemen, whose heads form a straight line. This horizontal grouping acts as a sort of entablature, supporting the triangular pediment composed of the slanting cloud masses and the figures of the Virgin Mary and St John the Baptist, with Jesus and the Holy

67 *Burial of the Count of Orgaz* Detail

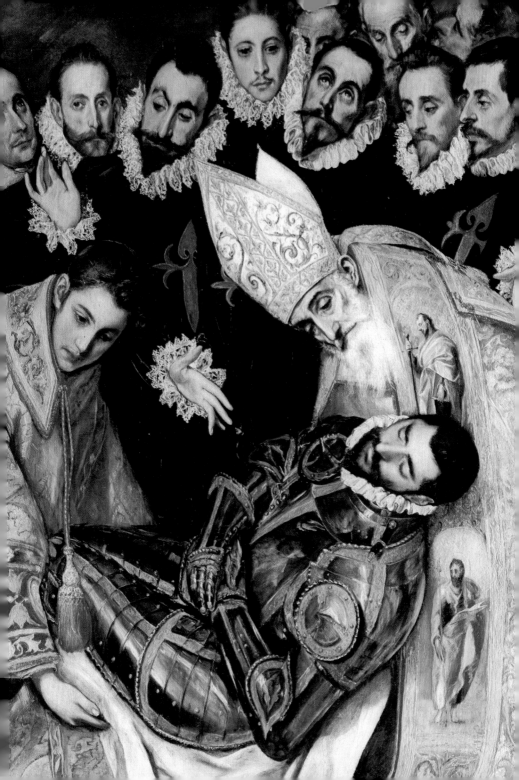

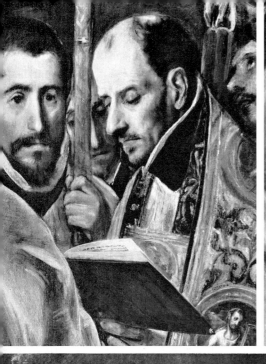
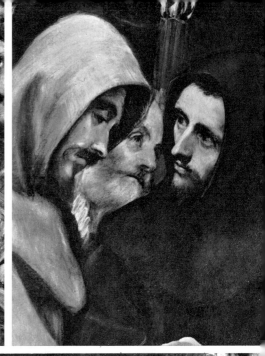

68–73 *Burial of the Count of Orgaz* Details

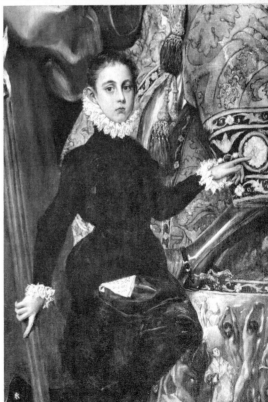

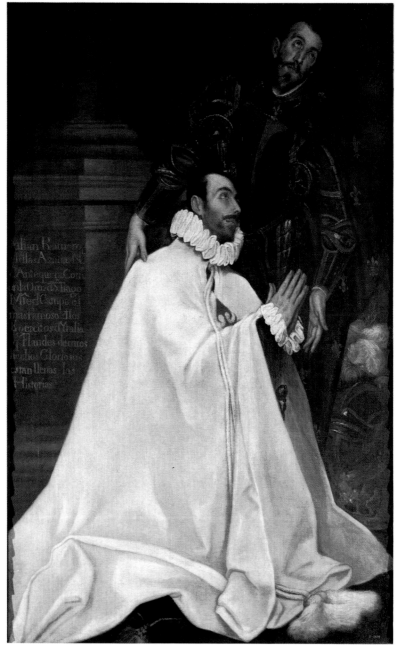

74 *Julián Romero de las Azañas and St Julian (or St Theodore,
or St Louis)* 1585–90

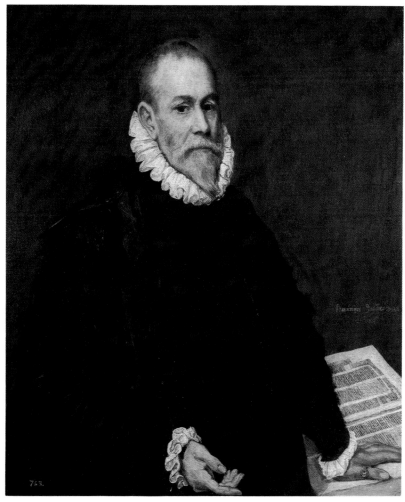

75　*Rodrigo de La Fuente (The Doctor)* 1585–89

Spirit making the apex of the triangle. The work is so rich in detail that it would be an impossible task to describe it in full. The chasuble worn by St Stephen, for example, merits lengthy examination; the scene of the stoning [73] is of particular interest because it

contains such detail in spite of its small scale, also because of the style of the elongated and spectral figures and the curious construction, both characteristics of the later works. Lost works by El Greco include one listed in the second of the two inventories made after his death, entitled *Stoning of St Stephen*. No doubt it is a similar composition in a larger format. The opulence and magnificence of the vestments worn by the two Saints, the Count's elaborate suit of armour, are technically particularly noteworthy. The scene of the miracle is integrated quite naturally with the cortège of onlookers.

The overall effect is one of monumental grandeur, and it is demonstrably false to suggest that the two zones could be separated without destroying the unity and profound symmetry of the whole. The interpenetration of the human and divine world, the acute observation of psychological types, the realistic treatment of the theme, and the social and documentary character of the painting, have given rise to many contradictory interpretations. The painting was executed in the context of a society that had attained its full spiritual maturity, one that had arrived at an understanding of God by means of human intelligence. Baroque extravagance and emphasis on outward show were still in the future. El Greco was not concerned with displays of pomp and circumstance. To the marriage of the Idealism of his native art with the Naturalism he had learned in Spain, he added his own very personal contribution, an original interpretation of the theme and a revolutionary handling of colour and form. Within the context of a particular race, age and

society, El Greco has created a work that has a universal validity, of a technical skill and mastery that have rarely been equalled. It inhabits a different world from his disturbed and often violent compositions or the theatrical Italianate canvases. The *Burial of the Count of Orgaz* is bathed in serenity, peace and simplicity. The miracle arouses no sensation of shock, but rather a silence before the solemnity of a scene which portrays the mysteries of death and resurrection.

But if this painting aroused the admiration of El Greco's contemporaries, the same cannot be said of succeeding generations. In the nineteenth century the critics praised the lower section, but thought the Glory was the work of a 'deranged' man. The coexistence in El Greco's work of two contrasting styles, the one founded in Naturalism, the other in the heightened response of the visionary (a dualism that is, after all, characteristic of most artists one could name), gave rise to the ridiculous theory that El Greco suffered from fits of madness. Pedro de Madrazo wrote, in 1880: 'El Greco painted the lower section while of sound mind but lapsed back into his fatal distraction before painting the upper half.' Yet the copy in the Prado, which is without the Glory, shows just how necessary it is to make sense of the lower section.

Cossío sees this as the one canvas that epitomizes all the qualities of the painter's work, not only at the period when he painted the *Burial* but ever since he had arrived in Spain: homely realism and mysticism; humanism and tragic sense; concentration and sobriety; equilibrium and disequilibrium; nervous intensity, control and lack of control; grey colours and strident

76 *Don Rodrigo Vázquez* 1585–90

colours; attachment to the past and visionary intuition.
This catalogue of the attributes of El Greco's work
reads like an evocation of Spanish society. The lower
section of El Greco's *Burial of the Count of Orgaz* was
for the sixteenth century what Gustave Courbet's

Burial at Ornans was to be for the mid nineteenth century: a protest against all false heroics and shoddy Romanticism; and a return to the Naturalist conception and to the profound and inexhaustible poetry of everyday life.

At the same period El Greco painted another *St Francis* [43] which brings to mind the figure of the Franciscan in the cortège in the Burial. In this painting, which is now in the Museo San Vicente in Toledo, St Francis is shown standing, and as if about to step forward; the spectator's interest is directed towards the expression of his emaciated face and of his hands, one of which is laid across his breast.

El Greco's version of the theme of the *Mater Dolorosa*, which is derived from Titian's, is entirely characteristic of his style: a long, pointed face, great black eyes full of an intense spirituality, a small, almost childlike mouth, hands clasped together as if in prayer. The best of his paintings of this subject are those now in private collections.

A *Deposition* known as the *Fifth Anguish* (Niarchos Collection, Paris) is unusual in its composition. The kind of *Pietà* that El Greco painted in his early Spanish period tends to have affinities with the miniature; but here the group takes on a grandeur which recalls Titian and Michelangelo, while bearing at the same time the unmistakable mark of El Greco's individual style. As in Michelangelo's *Pietà*, the Virgin holds Christ in her lap; she is flanked by St Joseph of Arimathaea and St Mary Magdalen. The faces of the two women bear the same expression of contained, pensive grief that is seen so often in the artist's other works.

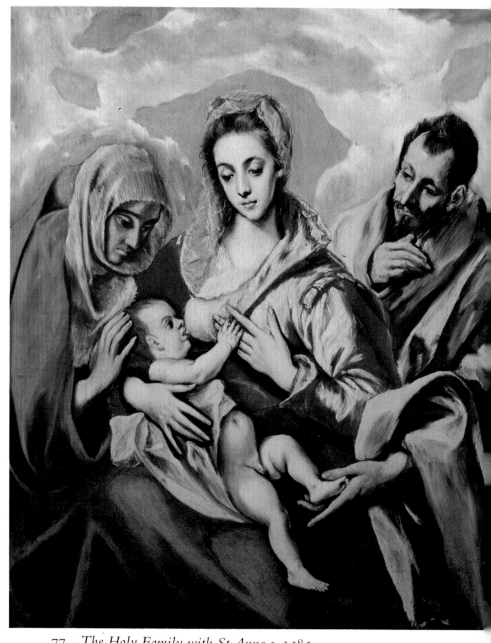

77 *The Holy Family with St Anne c.* 1585

78 *The Holy Family with St Anne* Det

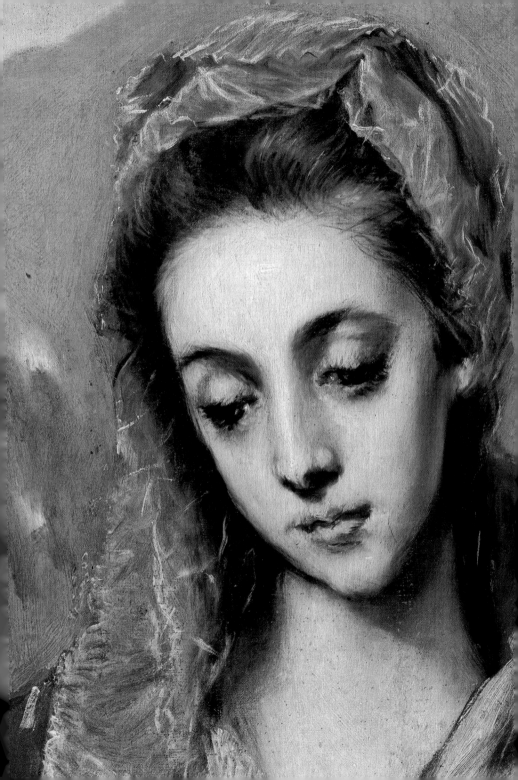

Around 1590 El Greco painted several versions of *St James the Greater* [79], showing the Saint dressed as a pilgrim; the most important of these are the works in the Museo de San Vicente, Toledo, which shows the patron saint of Spain standing against a gilt niche, and the one now in Budapest, which shows him in a Toledan landscape. In a later version, now belonging to the Hispanic Society in New York, the Saint is shown half-length, with one hand on his breast and his eyes turned upwards in an attitude of ecstasy.

From about 1590 onwards, El Greco's art passed through a critical period in which it underwent a series of profound transformations. The Roman and Venetian formulas had been left behind, along with Realism and Naturalism, and the figures became elongated and spectral; the colours and harmonies that now appeared are violent and audacious. There were now no commissions to hamper this upsurge of creative energy. Now that his themes were no longer imposed on him, El Greco was able to express himself freely without the obligation to conform to iconographical models sanctioned by usage. His art became increasingly intellectual, austere, spiritual, and abstract. In this El Greco set himself apart once and for all from the Italian Mannerists, who kept to the anatomical canons of the Renaissance.

It was his miraculous achievement to humanize even the most abstract of his creations in such a way as to suggest states of supernatural ecstasy. His forms seem to be torn between the spiritual forces which carry them upward and the profound humanity which gives them life. There is no contrast or conflict here, only a

79　*St James
the Greater
c.* 1600

unity which reinforces the tension of the composition.

During this period, apart from one commissioned work (the altarpiece of Talavera la Vieja, 1591–99), El Greco devoted himself exclusively to painting figures of saints in which he was able to try out the new formulas which he was to employ in the great altarpieces of the subsequent period. Some of the *Saints* of this period are among the noblest works he ever

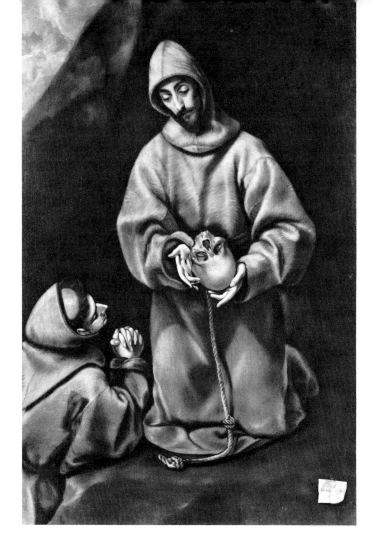

painted: they include St Andrew, St John, St Peter,
and two more paintings of St Francis, one kneeling,
with Friar Leo at his feet, the other shown in ecstasy.

El Greco's *Saints* have neither the impersonality of
High Renaissance images, appropriate to the painters
of the previous generation who regarded them as

symbols, nor do they have the anecdotal and descriptive dimension given them by the Baroque painters, who regarded them as actors in a play. El Greco conceives of them in purely aesthetic terms and, inevitably, they become fixed archetypes; he does not let them participate in the events that determine their historical personality. Their vocation is expressed within the form in which they are represented. Some painters are

80 *St Francis and Friar Leo Meditating on Death c.* 1590

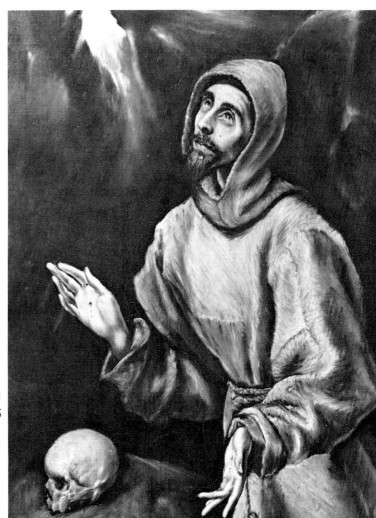

81 *St Francis in Ecstasy* 1590–95

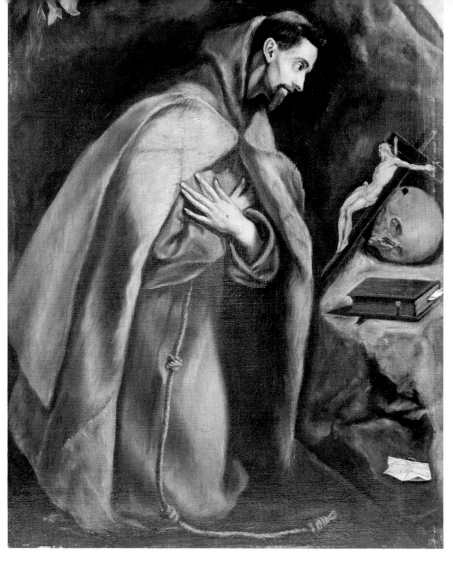

82 *St Francis in Meditation* 1590–95

inhibited in their freedom of expression by their concern for Naturalism or beauty. El Greco paints the outline of his saints so that their contours are as mobile

and volatile as their spiritual impulses, directly sym-
bolizing their vocation. The distortion and elongation
of the forms is the concrete expression of a state of
perpetual becoming, of the transient nature of the
moment, of creation constantly renewing itself. Like
the forms, the light itself is in motion, shot through
with reddish and white gleams that emanate from a
source in another world.

83 *St Peter in Tears* 1585–95

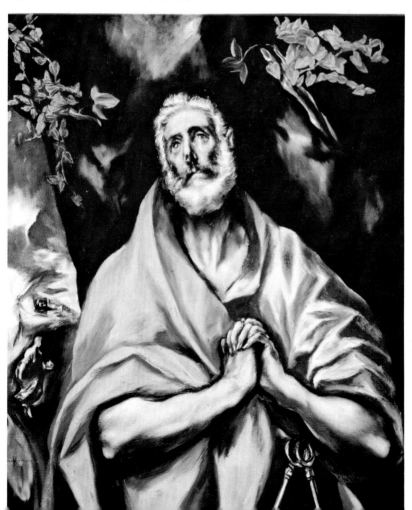

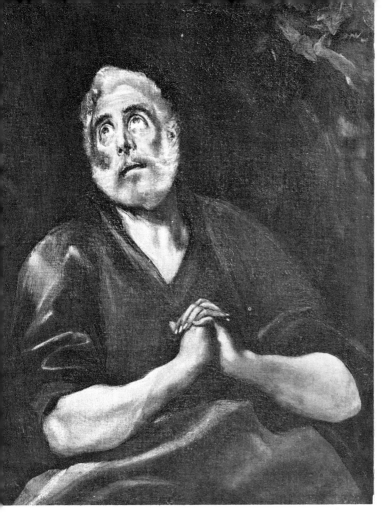

These saints, whether sunk in solitary contemplation or moving inexorably towards their allotted destiny, are often represented in pairs. This is not done for reasons of hagiographical accuracy, following the principle adopted by the Roman painters and sculptors who came to Spain to work on the Escorial, but in order to establish connections that bridge the centuries. For example, St Francis is often shown with St John or

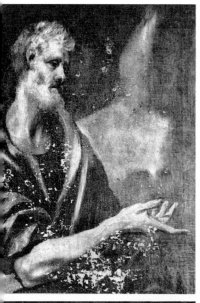

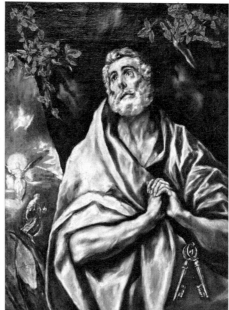

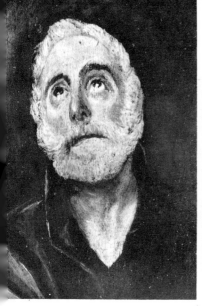

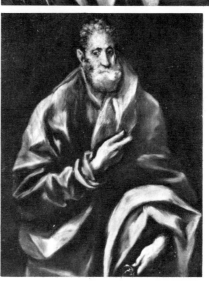

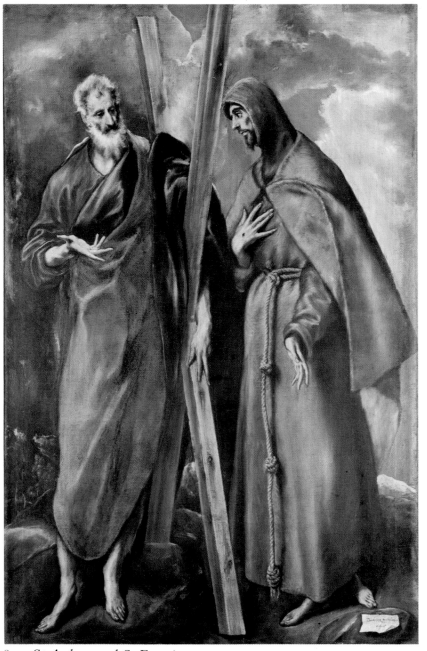

89 *St Andrew and St Francis* 1590–95

90 *St John the Evangelist c.* 1600

91 *St John the Evangelist c.* 1595

St Andrew [89]. The device enables the painter to point up contrasts within the one composition, by juxtaposing different outlines, for example, nude forms with flowing robes. It also leaves him free to lay the emphasis on attitudes and contrasts, rather than representing some dramatic event that would tend to destroy the dialectic established by their appearance together in the same picture.

The fact that El Greco painted so many pictures of the various saints, often in series like the *Apostolados*, relates to another significant innovation in his work. To each saint he gives the particular form that corresponds to his spiritual universe. To use Camón Aznar's fine expression, the saint appears to await his destiny. And we actually see this destiny being fulfilled. The representation of St Francis, for instance, develops along lines of increasing asceticism and purity, until the point is reached [97] where the Saint's companion

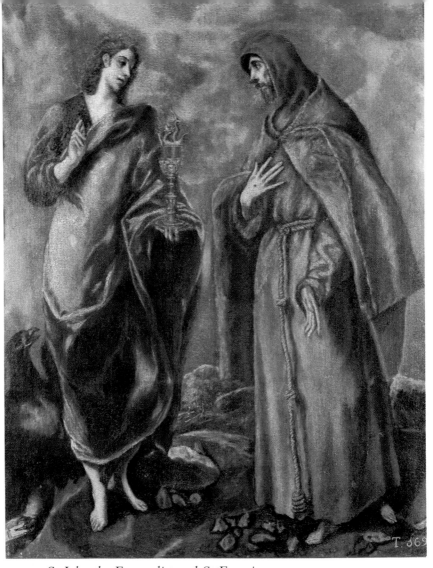

92 *St John the Evangelist and St Francis c.* 1595

Friar Leo, who has only earthly powers, reels back-
wards, quite unable to withstand the power of the
divine presence. In different versions of *St Peter in*

Tears, one of his favourite themes, El Greco conveys the profound humanity of the man as he stands before a symbolic rock wringing his strong peasant hands, a traitor and a sinner, saved by his penitence and un- shakable faith. Each theme establishes it own unity. By the end, *St Andrew* appears with his arms almost at one with the arms of the cross.

Although in each case El Greco creates a symbolic face, he sometimes endows a saint with the features of a living person. This transposition is particularly rich in interest because of the way he superimposes the attributes of sanctity onto a powerfully realistic por- trayal. There are for example several representations of *St Jerome as Cardinal* that depict the intense gaze and huge beard of Cardinal Gaspar de Quiroga. The same process is exemplified in two pictures of St Ildefonsus, in the Escorial and in Illescas, in which some humble canon of the times is shown transcribing the words that come to him from the Virgin Mary; his head is turned sideways and his face is lit up with ecstasy at the divine apparition.

In his endless lawsuits with his clients El Greco was often accused of giving his saints the features of some friend or relation. He is thought to have left portraits of himself in many of his works, for example among the noblemen in the *Burial of the Count of Orgaz*. The portrait that has the greatest claim to authenticity is in the *Pentecost*, where El Greco is the apostle second from the right. He shows himself with total objectivity, taking no part in the general exaltation. He is content to stand there as a clear-sighted witness of events, gazing fixedly at the onlooker.

El Greco painted many versions of *St Francis* at different times in his life. They were extremely popular especially among members of the Franciscan Order and so he was never short of commissions; many are of monotonous repetitiveness and were probably painted by his assistants, Preboste, Jorge Manuel and Escamilla, after originals executed by their master. Toledo boasted three Franciscan monasteries and seven convents of nuns of the Order, and that alone is enough to explain the extent of the demand for commissions and the innumerable copies that were made after El Greco's death, even to his signature being reproduced exactly. 128 paintings on this theme have been attributed with reasonable certainty either to El Greco or his studio, and the Saint is shown as eleven distinct types. These do not follow on in chronological order but crop up haphazardly in the painter's work; they can only be dated by differences in technique and by the evolution of the forms and individual motifs.

These various images display an increasing tendency towards economy, in techniques of expression as well as in the treatment of the background, where all the incidental details are progressively eliminated. Beginning with the sheer rocky landscape of the Bergamo version, it progresses by a process of simplification to the motif of the oak in the Italian versions and the picture in the Zuloaga Collection, to arrive at the schematization of the cavern with a background of sky in the early Spanish examples, and finally the insubstantial neutral background which concentrates all the interest on the expression of the face. In terms of iconography, the earliest Italian versions employ the tradi-

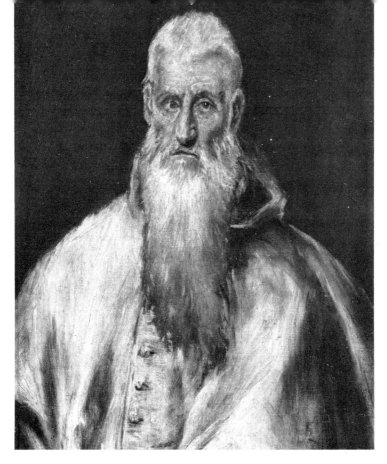

93 *St Jerome c.* 1595

tional facial stereotypes that had been in use since the
time of Bonaventura Berlinghiero, while in the first
Spanish period two distinct head types emerge: one
with a beard, with hints of Venetian influence, the other
tonsured and almost beardless.

It was in 1585 that the Saint was first represented with
the features that, with certain variations, he was to
retain until the end of the painter's life: huge rapturous
eyes, thin straight nose, parted lips, moustache and

pointed beard. The model is basically Italian, but El Greco lends it spirituality, emphasizing the Saint's unworldly and ascetic character and endowing him with an intense mysticism. The theme is stated simply, with none of the historical embroidery characteristic of the Middle Ages. The Saint is a straightforward devotional image expressing the ideal of sanctity authorized by the Council of Trent. No episode in his life is represented, he simply manifests those qualities assigned to him by popular imagination. After the first Spanish versions he is never again shown against the jagged rocks of Mount Alvernia, but always alone in a cave with a skull, a crucifix, and the Gospels provided for him by Friar Leo. Sometimes he is shown praying before a crucifix, at others in a state of rapture as he receives the stigmata [81]. Frequently Friar Leo appears, kneeling before the Saint in an attitude of prayer [80], but in the last versions he is eliminated altogether. There are various series, sometimes grouped together under the general title of *St Francis as Hamlet*, which represent the Saint with his arms outspread, receiving the stigmata, or kneeling and viewed from the front, holding the skull in his hands; it is perhaps the most surprising and original interpretation of him as a symbol of intense meditation. It would seem that this was a popular theme as there are still many copies in existence, in Toledo, in the Prado, and in many private collections and foreign museums. Another type, possibly later, shows *St Francis in Ecstasy*; he is seen from the front, standing, but leaning slightly forward in ecstasy before a light that comes from one corner of the picture. The cadaverous face, parted lips, emaciated cheeks and big staring eyes, are

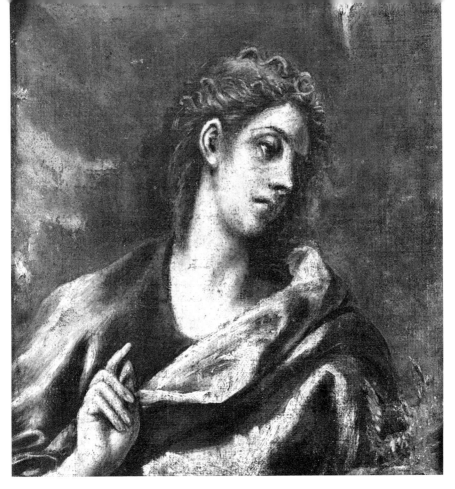

94　*St John the Evangelist* 1595–1600

of great expressive power; the best known examples of
this type are in the Musée des Beaux-Arts, Pau [81], and
in San Vicente in Toledo. Difficult to date is a series of
St Francis's Vision of the Flaming Torch, which shows the
Saint as a very elongated kneeling figure, with his arms
outstretched as he gazes in ecstasy towards the upper
corner. Friar Leo is seen from behind, seated on the
ground on the right-hand side of the Saint; he is sup-

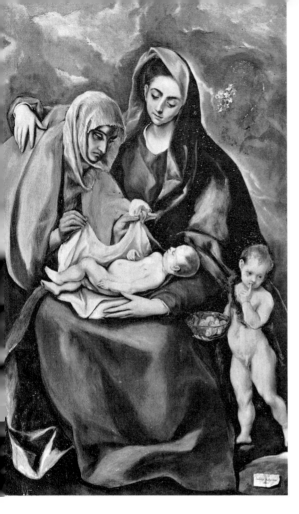

95 *Madonna and Sleeping Christ Child with St Anne and St John the Baptist* c. 1585

porting himself with one hand, his right arm is raised in the air; a strong light outlines the form. The most representative painting in this series is undoubtedly that in the Hospital de Nuestra Señora del Carmen, Cadiz [97]. It bears some resemblance to the Bergamo and Zuloaga versions, but in other respects is characteristic of the painter's later style and use of colouring. The work combines action and abstraction in a way

that is typical of the transition period before the paintings of the early years of the seventeenth century, and the attitudes, the colours and the movements of the masses are united in the same complex rhythms.

A new theme from this period is the *Coronation of the Virgin*, the finest example being the first version for the High Altar of Talavera la Vieja. Only three of the five panels are by El Greco, the *Coronation*, *St Peter* and *St Andrew*. The two pictures of the Saints are the first of a series of very elongated, almost monumental figures, their gestures large and expansive, and the folds of their garments conveyed with a sculptural richness of detail.

The *Coronation of the Virgin* repeats the device of the bi-partite composition: above, the Virgin Mary is crowned by the Holy Trinity, the whole group being supported on a base of clouds; below, a number of saints are gathered about a chalice as they watch the mystery. While the technique of using two zones is far from new in El Greco's work, the treatment of the figures and the colouring have all the signs of his later manner. The faces of the saints are typically Toledan, and the bare torso of St John the Baptist, stretching out his long arm, is finely and richly modelled. (Paul Guimard has written a long descriptive analysis of the altarpiece in *Revue des Arts*, 1926, p. 175.)

There are three iconographical categories of the Holy Family in El Greco's work. In the first, the Virgin is shown feeding the Child, watched by St Joseph [77]; in some versions, like that in the Szépmüvészeti Múzeum, Budapest, St Anne is also included. There is also a variant on this motif, today in the Cleveland

Museum of Art, Ohio, which is compositionally reminiscent of Leonardo da Vinci and Michelangelo: the Virgin is seated on her mother's knee, as in Leonardo's *St Anne*, while St Joseph resembles Michelangelo's representation of him.

The *Holy Family* in the Hospital of San Juan Bautista in Toledo, *c.* 1585, is a most striking use of the motif, and the head of the Virgin is one of the most beautiful ever painted by El Greco; the same typically Spanish features are portrayed in other of the painter's compositions. St Anne and St Joseph are less good, but the contrasts provided by the reds, blues, yellows and whites, standing out against a beautiful blue sky with a pattern of subtly drawn clouds, are incomparably fine. The painting was restored in 1945 and the colours have regained their original lustre and transparency. Other variations on this motif include the figure of St John the Baptist as a child. The first version may be the example in the Museum of San Vicente in Toledo. The picture in the Prado is probably rather later and is a superb illustration of El Greco's ability to convey the decomposition of light. The quivering brushstrokes reinforce the mood of instability and flux that runs through this work, and the characters appear to move within a setting that is itself in perpetual motion.

There are many depictions of pairs of saints [89, 92] that date from this period, among them some of the finest canvases El Greco ever painted. The elongation of the figures, the expansiveness of their forms, the perfection of the design and their nobility of attitude, all give the figures a rare monumentality, that is enhanced by the landscape backgrounds.

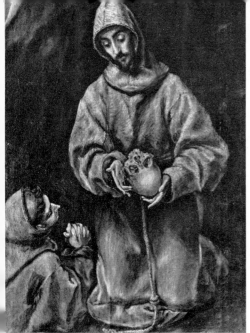
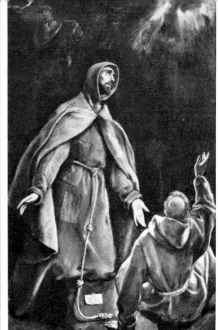

96, 97 *St Francis and Friar Leo Meditating on Death c.* 1600
St Francis's Vision of the Flaming Torch c. 1595

Among the finest examples are the *St John the Baptist and St John the Evangelist* in San Juan Bautista, Toledo, and the *St Andrew and St Francis* [89] in the Prado. The colours are brilliant and pure, and the greens, blues and crimson-tinted greys stand out vividly against the pale blue of the sky, the big scurrying clouds and the dazzling white of the snowy mountains.

St Peter in Tears [83–88] was one of El Greco's favourite themes. The Saint is shown half-length, and El Greco abandons the calm grandeur of the pictures we have described above, in favour of a Naturalistic style in which the modelling is accentuated and the face, racked with grief, the eyes filled with tears, becomes the focus of interest. Of the seventeen known versions, the earliest is probably the painting in the

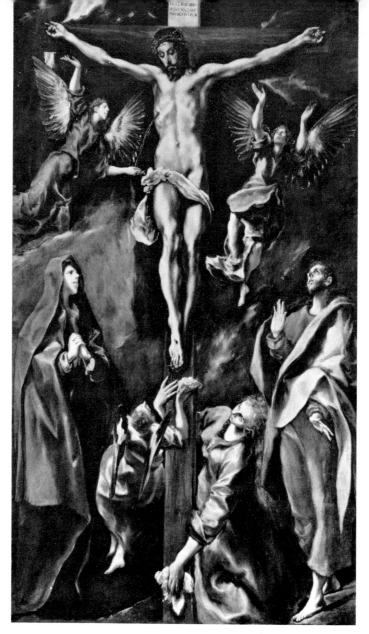

98 *Crucifixion* 1590–95

collection of the Marquis of Casa Torres in Madrid, and the finest is in the sacristy of Toledo Cathedral. El Greco and Annibale Carracci were the first painters to use this motif, no doubt finding inspiration in such Italian poems as Transillo's *Lacrime di San Pietro*. The version in the Hospital of San Juan Bautista, in Toledo, reverts to the imposing style of the previous works and the background is of striking beauty.

Of all the representations of St Dominic of Guzman in El Greco's work, the finest are the version in Toledo Cathedral, which is signed, and the example in the San Vicente Museum, also in Toledo, in which the contrast between the white tunic and black cope heighten the expressive humility of the Saint's pose.

A major work which may belong to this period is the *Resurrection* [122] in the Prado. It has very little in common with the earlier paintings for the retable of Santo Domingo; by the time he painted this canvas El Greco had found his own personal style and was at the peak of his technical perfection. The painting, which is signed, is quite disconcerting in its frenzy and dynamism, the impetuosity of the characters as they prostrate themselves at the feet of the sovereign apparition of Christ or raise themselves up towards him. The impassioned gestures, the expressive power of the elongated figures, impart a vertical motion to the whole composition. The mass of the fallen warrior in the foreground serves to enhance the verticality and weightlessness of the other figures with their raised arms. It is like an explosion, out of which rises the calm, beautiful person of the Saviour, glorious in his nudity. The colours are not conceived of in terms of contrast, the

palette is muted and bronzes, purplish-blues, greys and dark greens predominate, against a background of greenish-grey.

It was also during this period that El Greco painted his first *Crucifixion*. The version in the Prado [98] is a composition which almost totally ignores the inherent drama of the scene. It is not Christ's agony we see but his rapt contemplation of the abstraction of death; in a realm of silence, his solitude is total, expressed by a certain stiffness of the figures. St John and the Virgin Mary have distinctively Spanish features, and the monumentality and extreme elongation of their forms show the direction in which El Greco's work was moving. The green robe and red cloak of St John stand out against the sombre colours worn by the Virgin. Mary Magdalen and an angel hold the foot of the cross. The Virgin's face is powerfully expressive, suggesting pain and suffering in a few essential lines.

El Greco painted several versions of Christ on the cross, the earliest probably the painting now in the Louvre. Here there is nothing of the sense of collapse most painters give to the body of Christ, but a soaring rhythm a coiled power in the body that lifts the whole composition. A holy man and a layman observe the scene, set against a sky rent by jagged clouds. In other versions Christ is alone on his cross with no one to share his agony; the background is the Toledan landscape, in which a line of horsemen is visible. Examples are in the Zuloaga Collection, Zumaya, the collection of the Marquis of Motilla in Seville, and in museums in Cincinnati and Pennsylvania.

Altar Period: 1596–1605

Possibly this period produced the most representative of El Greco's works. All traces of Realism have vanished, the sculptural treatment of the figures has given way to airy brushstrokes and a mass of floating colour, a painting manner that lends itself to flights of the imagination. In this period of transition between centuries, El Greco created long, thin, hallucinatory forms, detached from the earth in permanent levitation. His colours too became dematerialized, lacquers of madder, translucent yellows, soft burnt siennas, watery greens, dazzling whites, colours that seem to take on a separate life of their own, like iridescent reflections. His new manner capitalized on his earlier experiments and reached its height of perfection in the great altarpieces commissioned from him at this time. Where previously he had tried out new effects on single figures, he now deployed them in compositions of increasing complexity in which his genius found the scope for its full expression. In these new works, figures and backgrounds alike are caught up in one thrusting dynamic move upwards, a soaring, vertical ascension to God. Every space is filled and there is practically no perspective. There are dense, tightly packed groups, whether of people, clouds or symbolic objects. And the scenes are bathed in a phosphorescent light that seems to emerge from the rents in the sky.

By this time El Greco's reputation had spread well beyond Toledo, he therefore received major commis-

133

99 *Allegory of the Order of the Camaldolesi* 1597

sions which gave him much greater scope. The first
great enterprise of the period was the decoration of the
Chapel of San José, whose three altarpieces were
painted between 1597 and 1599. The iconography of
St Joseph is established here in the most complete rep-

resentation of the Saint in the history of art. The works painted for this chapel, though not without a certain amount of ardour, have, on the whole, an air of gentleness and peace, comparable to the mood that he conveyed in his *Madonna and Child* pictures.

The altarpieces for the Colegio de Doña María de Aragón in Madrid, commissioned in 1596 and completed in 1600, demonstrate the ultimate expression of the elongated figures and spectral lighting of which El Greco was by then master. El Greco had evolved a personal system and language of representation. To the early years of the seventeenth century belong the painting of *St Bernardine* [117] of Siena, also the retable for the Hospital de la Caridad, Illescas; a new theme, the *Agony in the Garden*; and several treatments of earlier iconographic types, notably *St Francis as Hamlet*, the *Holy Family*, as represented in the Prado version, and *Christ on the Cross*.

It is important to explain the particular significance of the altarpieces dedicated to St Joseph. St Theresa described St Joseph as 'the father of my soul', and all foundations dedicated to her were placed under his protection. In the sanctuaries built by the Jesuits there was always a chapel dedicated to St Joseph. El Greco's painting shows him as a majestic figure walking along, guiding and shielding the Infant Jesus, who clings to his robe; the background is of the Toledan countryside. The Saint is crowned by a fine swirling flight of angels, their forms foreshortened. The red of the child's tunic contrasts with the greeny blue of the Saint's robe and the yellow of his cloak. The grandeur of the composition comes from the aerial perspective of the land-

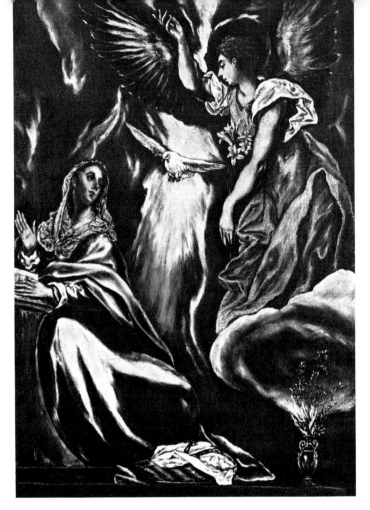

100 *Annunciation* 1600–05

scape in the background, in which various sites and monuments of Toledo are recognizable, while the Saint himself stands in the cosmic space that occupies three-quarters of the canvas. The whirling movement of the angels contrasts with the serene and gentle attitude of the Saint.

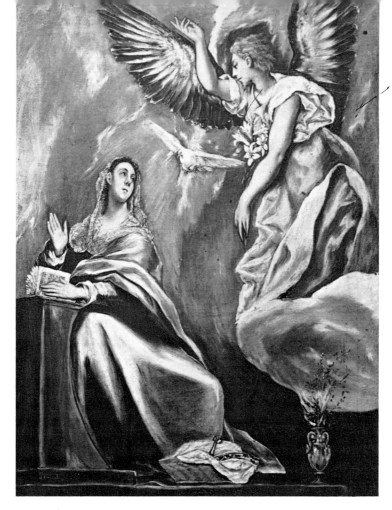

101 *Annunciation* 1600–05

In the San Vicente Museum in Toledo is a picture very similar to the central panel of the San José retable, although the scale is reduced. The *Coronation of the Virgin* which is placed above *St Joseph and the Infant Christ* is a beautiful imposing composition which includes the figures of the two SS John in the foreground.

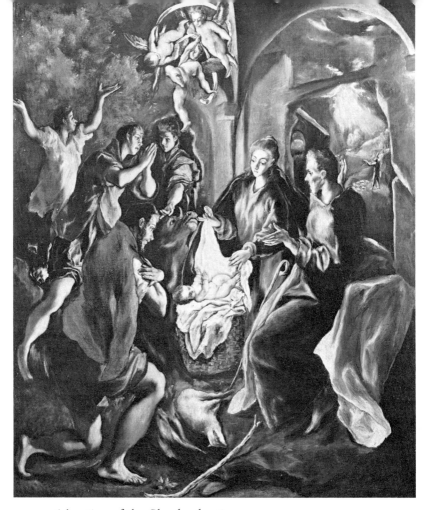

102 *Adoration of the Shepherds* 1605

The canvases of the two lateral altars have been replaced
with copies and the originals are today in the National
Gallery, Washington. The *Madonna and Child with St
Agnes and St Martina* [115] is one of the most poetic and
infinitely graceful of El Greco's works. The Virgin
Mary appears to hover between the two angels, as

103 *Agony in the Garden c.* 1605

though sketching out the steps of some holy dance. As she holds the hand of her Son she has a very feminine and maternal air. At her feet, separated from her by the cherubim and the clouds on which she rests, are the two willowy figures of the Saints; the one on the right, holding a lamb, is virtually a portrait of an elegant woman in a red cloak. The Virgin herself wears a greenish-blue cloak over a red robe shot with gleams of light. The pinks and greens of the angels enhance the pictorial beauty of the panel.

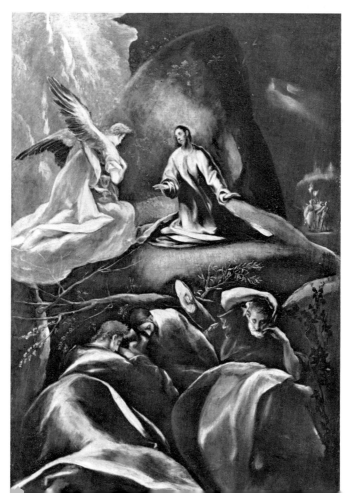

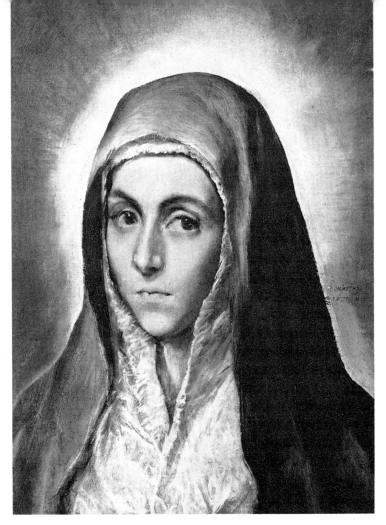

104 *Virgin Mary* 1596–1600

The wing of the other lateral altar is one of the most intense compositions ever painted by El Greco, *St Martin and the Beggar*. The distortion of the beggar is even further emphasized by the huge horse and the long figure of the knight. The work is full of carefully contrived contrasts: the thinness of the beggar and his

positioning high on the left-hand side of the canvas; the metallic reflections of the colours against the dazzling white of the horse and the rich armour worn by the Saint; the blend of Realism and other-worldliness that gives the scene its dreamlike quality, an effect enhanced by the eerie background of shadowy and pallid green. Variations on this motif appear in pictures in the Art Institute of Chicago, in the National Gallery, Washington [112], and in several private collections.

There is a lack of information about the retable for the Colegio de Doña María de Aragón, and it is not known how many canvases it consisted of nor the themes represented. It seems certain that the *Baptism* was included, but speculation is rife as to the identity of the other canvases. Cossío believes the Villanueva y Geltrú *Annunciation* was part of the ensemble, and he also makes a case for the *Resurrection* and the *Crucifixion* in the Prado, which date from the same period, but he does not actually attribute them to the retable. Mayer suggests that the Bucharest *Adoration of the Shepherds*, the *Crucifixion, Baptism, Resurrection* and *Pentecost* (all in the Prado), and the Villanueva y Geltrú *Annunciation*, all make up an ensemble, destined 'perhaps for the church of the Colegio de Doña María de Aragón, forming the retables of the High Altar and the lateral altars'. Other theories have been put forward but cannot be proved one way or the other. Camón Aznar believes there were only three canvases: the Villanueva y Geltrú *Annunciation*, the *Baptism*, probably forming the central panel because of its greater height, and the *Adoration of the Shepherds*, formerly in the Romanian Royal Collection.

The Prado *Baptism* [120] is, from a technical point of view, one of El Greco's most amazing achievements. Everything is in flux, transitory and evanescent. The colours are iridescent, a continual play of reflections and dazzling bursts of light. The nervosity of the brushwork lends the composition its giddy sense of movement. There are two overlapping zones. In the lower section, which shows the baptism itself, angels in blue robes hold a red cloth over Christ's head. In the upper section, God the Father appears in the centre of an oval frame consisting of the host of angels all around him. There is no empty space at all, no use of perspective to create order out of these packed forms and blinding bursts of light. The brushstrokes are separate, nervous and powerful. The overlaid colours are dense, vibrant and sparkling.

In the Galleria Corsini in Rome is a replica of this picture, possibly contemporary, although sometimes held to be a later work. The *Baptism* [119] in the Hospital Tavera differs in certain respects from the one described above; it is thought that the design and colour scheme were the work of El Greco but that it was in all probability Jorge Manuel who painted the picture. The spatial organization is entirely different, and there are conventional perspectives and a sense of depth that are absent from the version in the Prado.

The second painting that is likely to belong to the retable of the Colegio de Doña María de Aragón is the *Adoration of the Shepherds* formerly in the Romanian Royal Collection. Its size and technique would tend to suggest that it is contemporary with the *Baptism*. It is an equally dense, bi-partite composition, conceived of

entirely in vertical terms. It is a nocturnal piece and is probably inspired by Bassano's treatments of the *Nativity*: there is a version of the Bassano picture in the Prado in which the play of light and shade, and the positioning of the shepherds, is very similar to the El Greco painting. The light radiates out from the Child, illuminating the people about him, and the rest of the scene is plunged in shadow. The St Joseph is the first example of an iconographic type used by El Greco on many later occasions. A ruined church divides the scene from the upper half of the picture, which shows foreshortened angels descending to earth. The replica in the Colegio del Patriarca, in Valencia, omits the angel praying at the Virgin's side. As there still exists an engraving of this picture, executed by Diego de Astor in 1605, it seems reasonable to suppose that the original painting dates from a year or two before that; this would tend to be confirmed by the style and technique of the painting, which are similar to the retable for the Hospital de la Caridad, Illescas, discussed in detail later. Another variant on this theme, the picture now in the Metropolitan Museum of Art, New York, belongs to the last period of the painter's life; the resplendent, dematerializing forms are shot through with flickering light that blots out all impression of relief.

Another *Adoration of the Shepherds* crowns the altar of Santo Domingo el Antiguo: this is in the painter's last manner and is the canvas that originally stood above the altar of the chapel where El Greco was buried. It is difficult to be quite sure about the date of the work but, as El Greco made the arrangements both for the altar and for his funeral in 1612, it is reasonable to suppose

143

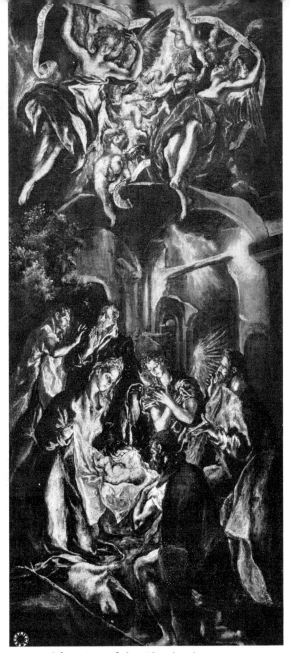

105 *Adoration of the Shepherds* 1597–1600

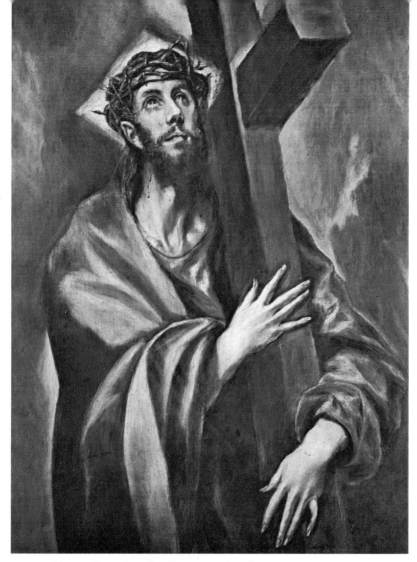

106　*Christ Carrying the Cross* 1596–1604

that the painting was executed after that date, making it one of his last works. Although it is no longer in good condition, it typifies his last manner, with its grant foreground figures, massive monumentality and vertical

foreshortenings. The light is not so blazing and hectic as in the earlier pictures, there is a heaviness and a strange eeriness about it, and the figures are superimposed without any effect of distancing.

The third painting thought to belong to the retable is the *Annunciation* in the Museo Balaguer, Villanueva y Geltrú. Here El Greco abandons the classical conception of the *Annunciation*, also the device of dividing the composition into two zones. The Virgin Mary seems almost to float, insubstantial, in a heavenly world peopled with cherubim, bathed in the streaming light of the Holy Ghost that is coming down to her; facing her is a monumental Archangel Gabriel, who is leaning forward against a cloud and supporting a host of angelic musicians on his outspread wings. The dazzling light of the Holy Spirit, shining down onto the scene, brings out the sparkle and transparency of the superb range of colours: the pale red of the Virgin's robe, the sea green of her cloak, and the bright green of the cloak worn by the Archangel. Other versions of this theme are in the Contini-Bonacossi Collection in Florence and in the Museo de Bellas Artes, Bilbao. There are also slight variations, as for example in the painting of the Church of San Vicente, which shows the Virgin kneeling at a prie-dieu and the angel also kneeling, on a cloud; the angelic musicians are omitted. As in many of the works of the final period, the colours are denser, the greys darker, the masses more compact, and the atmosphere constricting. Of some curiosity is another version which has actually been divided into two sections: the scene of the *Annunciation* [121] is in the Urquijo Collection in Madrid, and the *Angel Concert* is in the Athens

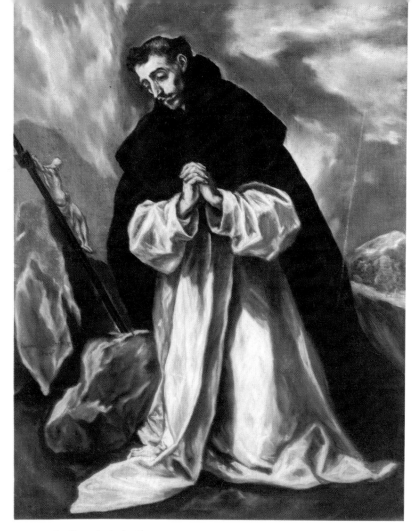

107 *St Dominic in Prayer* 1598–1603

Pinacoteca. The former, inspired by Michelangelo, represents the Virgin and the Archangel Gabriel; they are shown within the perspective of an interior, and there is a tiled floor, on which an angel is walking, also a dais which supports the Virgin. The realism of the setting is somewhat reminiscent of Michelangelo, but

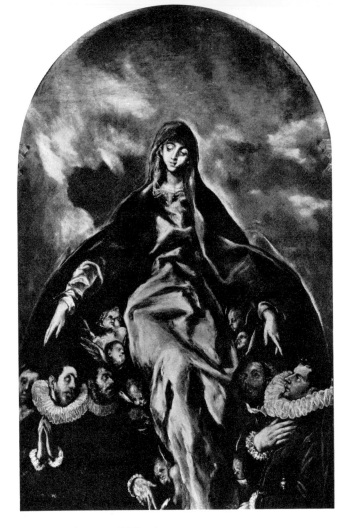

108 *Madonna of Charity* 1603–05

the characters are entirely typical of El Greco's last manner, gigantic in scale, distorted and elongated. The angels in the section of the picture now in Athens have lost all corporeality, and form a quivering, undulating mass, blurred by movement. Camón Aznar believes this picture was painted after 1610.

Disputes over payments for commissioned works involved El Greco in many lawsuits, and these help to give an approximate date to some of his works. The lawsuit concerning the valuation of his work for the Hospital de la Caridad, Illescas, a place midway between Toledo and Madrid, took place between 1605 and 1607. We may therefore assume that the paintings destined for the Church, the *Madonna of Charity*, the *Coronation of the Virgin* [109], the *Annunciation* [111] and the *Nativity*, were painted between 1603 and 1605. At this period El Greco habitually returned to themes he had long since abandoned. The only exception is the

109 *Coronation of the Virgin* 1603–05

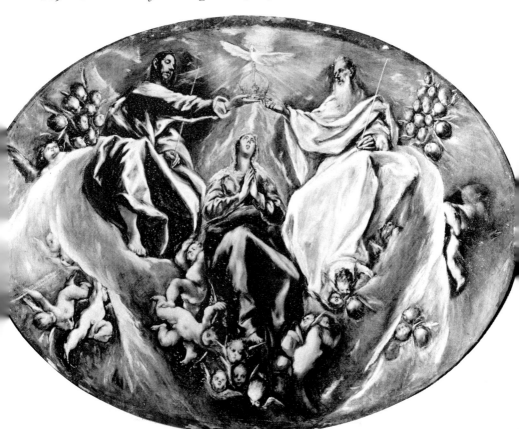

110 *St Joseph and the Infant Christ* 1597–99

III *Annunciation* 1603–05

Madonna of Charity, which shows the Virgin sheltering a band of *hidalgos* in the folds of her immense cloak; these are probably portraits including, it has been suggested, one of Jorge Manuel.

The Illescas *Coronation of the Virgin* [109] is the most abstract and transcendental treatment of this subject. Its oval form possibly helps to reinforce the absence of depth and perspective. The characters are evenly distributed over the whole surface. The figures of the Father,

the Son and the Virgin float in a sky flooded with coloured light; the carmincs, blues and yellows shimmer with a metallic sheen and are almost without chromatic density. Other versions of this theme, oval or rectangular in format, and presumably roughly contemporary with the Illescas painting, are in the Prado (Bosch Bequest) and in Chicago (Max Epstein Collection).

The *Annunciation*'s [111] round format enables the artist to dispense with supplementary details, and so to achieve a more concentrated and simplified composition. The picture shows the Virgin and the Archangel, who is of unnatural height, caught up in a sinuous dancing rhythm of splendid energy.

The *Nativity* is also in a round format and is a very beautiful representation of this theme, showing the characters grouped in the semi-darkness and lit up by the light radiating from the Child. In a curious touch, the whole scene is viewed over the large ox's head which occupies the foreground of the picture.

In 1603 El Greco was commissioned to paint a *St Bernadine* [117] for the College of San Bernardino in Toledo. The Saint is represented standing on a rock, above an aerial view of a town situated at the foot of a mountain. The huge figure stands out against the pale sky that fills almost the whole of the rest of the picture, a device often employed by El Greco to accentuate the already disproportionate height of his characters. Contrasting with the Saint's grey habit are the three mitres on the ground beside him, their embroidered silks and precious stones gleaming. Today this picture is in the Museo del Greco in Toledo.

152

The *Agony in the Garden* [103] introduces a new iconographical theme into El Greco's work. In many versions, some of which date from the period under discussion, Christ is shown kneeling in the centre of the picture in front of an angel. The setting is a weird, unreal garden where, depending on the version, the disciples are shown either sleeping in the foreground, or in a cave lit with a ghostly light. Each element is treated in isolation from the rest: Jesus praying, the angel, the three apostles, and, in the background, a spectral troop of marching soldiers, bearing torches and passing by a distant city. It is the moon, glimpsed through the clouds, that gives the picture its mood of unreality. The earliest versions of this motif are the picture in the Herzog Collection in Budapest, which was painted after 1600, and the painting in the Musée des Beaux-Arts, Lille [114]. Those showing the apostles inside a curious cave, of some transparent crystalline structure, are in the National Gallery, London, and the Art Museum of Toledo, Ohio.

It was in about 1600 that El Greco returned to the theme of the *Purification of the Temple*. Aznar suggests that it was nostalgia for his youth that made him look back to his days in Venice for subject matter, and indeed that this was sometimes the reason why he reverted to Byzantine techniques. Or he may simply have wanted to treat some of his old themes in his new manner, a common enough impulse for an artist in any century. Of all the versions that date from this period of his maturity, the best examples are in the National Gallery in London [113], the Frick Collection in New York [116] and the Fogg Art Museum in

112 *St Martin and the Beggar* 1597–99

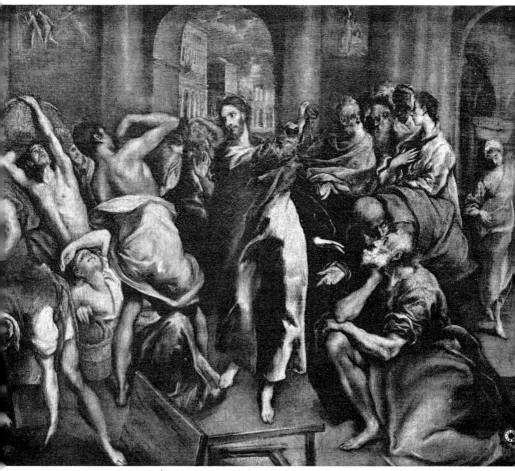

113 *Purification of the Temple c.* 1600

Cambridge, Massachusetts. They are a convincing demonstration of the radical transformation of El Greco's painting. The rounded noble forms, tranquil Realism and Venetian atmosphere are replaced, in El Greco's last works, by a spiritualization of the characters, a new intensity of expression, a concentration, a simplification. Here, it is the Christ figure with his

155

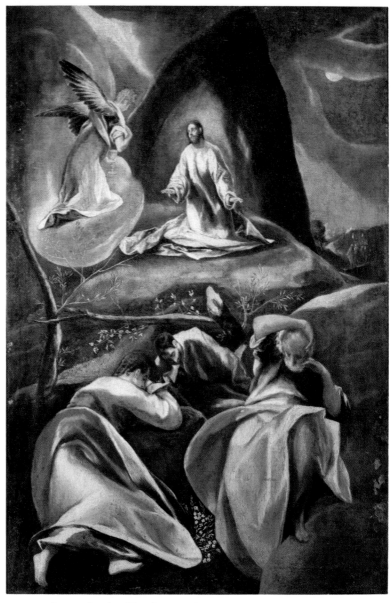

114 *Agony in the Garden c.* 1605

115 *Madonna and Child with
St Agnes and St Martina* 1597–99

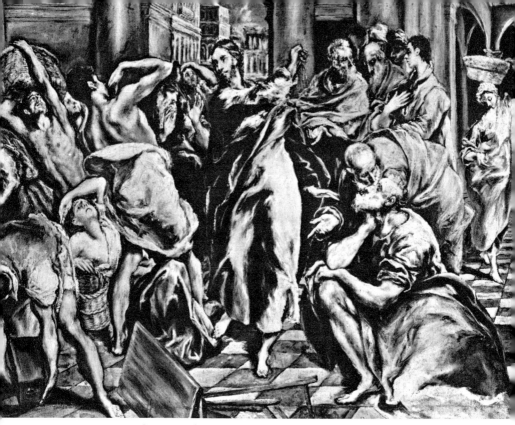

116 *Purification of the Temple* 1595–1605

red robe and green cloak who is the centre of interest
in the composition. It is his avenging gesture and almost
dancing posture that unleash the movement all about
him. The architecture is different too, reduced to a
chiaroscuro of solid, immense structures. The hori-
zontality of space has disappeared and all the action is
concentrated in the foreground. The anecdotal charac-
ters are also gone, leaving the main characters in the
drama. The bare torsos of the slaves on the right-hand
side of Christ are of great beauty, as too are the old
men to the left of the picture.

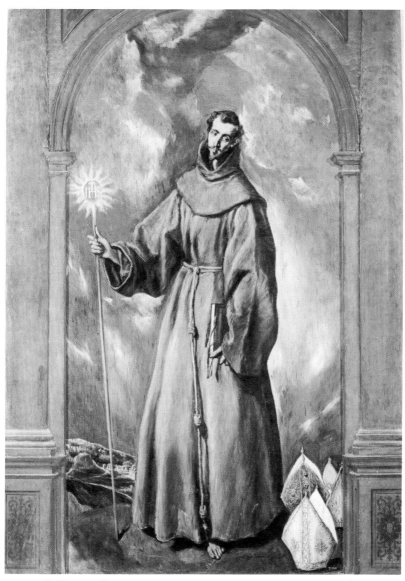

117 *St Bernardine* 1603

Final Period: 1605–14

The interest in new forms, which had begun to pre-occupy El Greco since his fiftieth year, continued to be reflected in the work of his final period. Yet he moved easily between compositions of total freedom and portraits and images of saints of profoundly humanist mood, among the most realistic he ever painted, even though the spiritual content is greater and is at times expressed in terms of elongated forms. His technique became increasingly bare and transparent. For the first time he painted true landscapes, and embarked on a subject taken from mythology, the *Laocoön*.

His palette became muted and subtly expressive, ochres and burnt siennas dominate the backgrounds and the shadows and the large surfaces of colour are divided into shimmering reflective highlights. White light floods over the canvas, especially over the passages of red and green. Silvery grey, carmine and purple appear with increasing frequency, thinly applied so that they barely cover the painting surface. Construction in depth disappears almost entirely and the planes of colour are simply juxtaposed. A sense of movement invades the whole canvas, in terms of composition and also in the rapid, nervous handling of the airy and transparent brushstrokes.

During this period El Greco added another type to his series of *St Francis*, showing him this time in profile, with his left arm stretched out in front of him and his

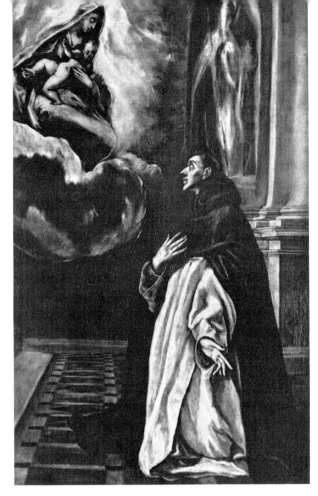

right hand resting on his breast; he often appears half-length, sometimes only the head is represented. Incidental details are omitted and the expressive power is concentrated in the face and hands.

There are two almost identical versions of *St Hyacinth* [118], one in a private collection and the other in St Louis in the United States, showing the Saint kneeling on a marble floor in front of an altar, above which the Virgin and Child are descending in a cloud.

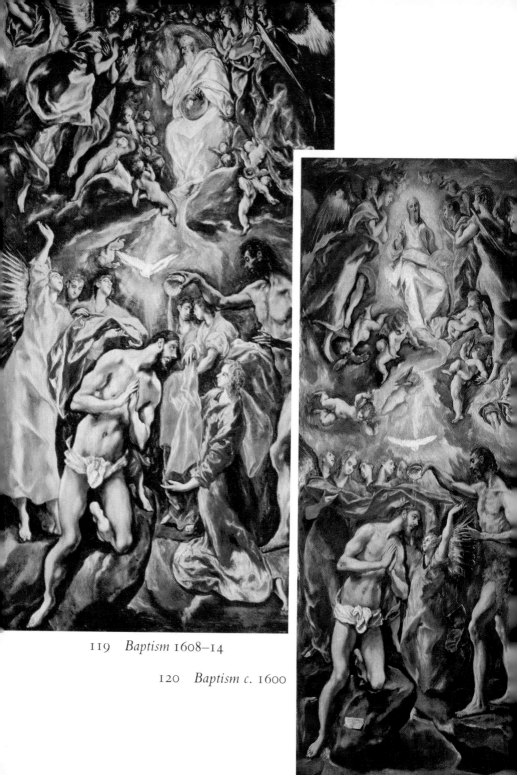

119 *Baptism* 1608–14

120 *Baptism c.* 1600

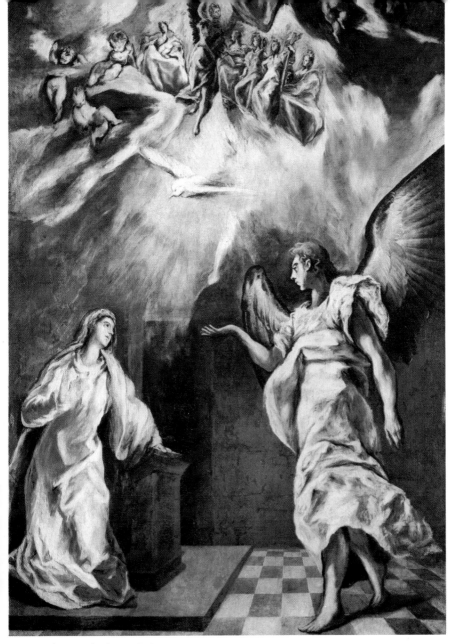

121 *Annunciation* 1608–14

In the background are two columns and a niche containing an image of St Augustine, though this is treated as little more than a sketch. The Saint's iconography is similar to that of St Dominic, both in the pose adopted and in the contrast between the white robe and sober cloak.

The Illescas *St Ildefonsus* [125], later than the retable, is a portrait of a Saint who has particular connections with Toledo. He is shown pen in hand at his desk, writing his book on the virginity of Mary. In the legend the Virgin is said to have appeared to him with the book in her hand, but El Greco represents her holding the Child. Cossío thinks both the setting and the character are typically Sevillian and sees the painting as, in effect, a portrait of one of the learned ecclesiastics such as are described by Spanish authors. The Saint is shown as a scholar of the day in a room of restrained luxury, seated in a chair that is embellished with bronze ornamentation and red silken tassels. The table is covered with a richly embroidered fringed cloth of scarlet velvet. As the man looks up from his writing at the apparition of the Virgin, his face shines with gentle good humour and calm joy. Here El Greco put aside the other-worldly distortions of the paintings for the Colegio de Doña María de Aragón, and returned to tangible reality.

The *St Ildefonsus* [126] in the Escorial shows the Saint standing, wearing a mitre, and holding his crook in one hand and a book in the other. The mitre and the chasuble are executed with great mastery and technical perfection. The colours gleam frostily, pale golds, pinks and mother-of-pearl, and the suffused

pallor of the face stands out against the cloudless, overcast sky.

It is probable that this version of *St Ildefonsus* is contemporary with the *St Peter* [129] that is also in the Escorial. He is a figure of striking grandeur, standing on the ground but rising up immensely tall against the expanse of sky in the background. His garments are swelling in the wind. The colours too are astonishing, the yellows of the cloak contrasting with the blue of the sky, itself flecked with ochre, and the blue of the patch of tunic, against which a bony hand is sharply outlined.

The three types of *St Jerome* painted in the last years also belong to this line of ascetics. One is described in the inventories of El Greco's works as *St Jerome as Cardinal*; there are several examples, in the National Gallery in London, the Frick Collection in New York, and in private collections in Madrid and Barcelona. The expression on the Saint's gaunt face, and the long yellowy-grey beard, tumbling down onto the faded red of the cape, make it an imposing creation. One of his hands is resting on a folio volume while the other marks a passage in the text with the thumb. The figure has none of the emblems or attributes of sanctity, and has indeed been taken as a portrait of a Venetian Doge, whom the Saint resembles, although the hieratic attitude and stiffness of the pose are equally reminiscent of Byzantine icons.

There are several variants on *St Jerome in Penitence*. One of the most common of all shows the Saint at the rear of a cave flagellating his naked torso. All the emblems are present: the ivy, the red cardinal's hat,

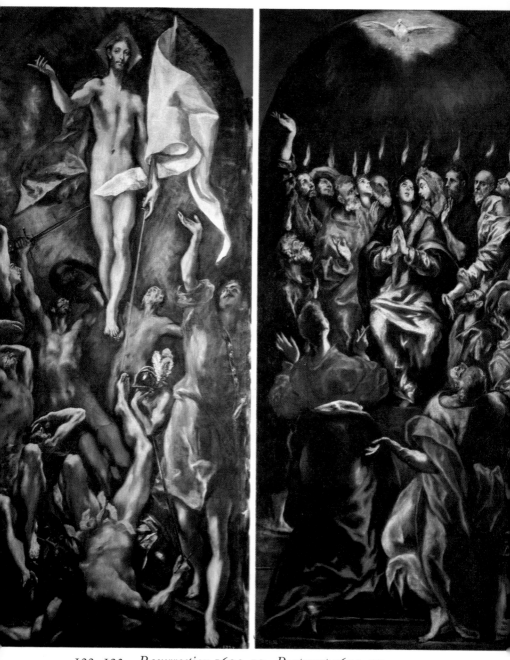

122, 123 *Resurrection* 1605–10 *Pentecost* 1605–10

124 *St Jerome as Cardinal* 1604–10

the book, skull and hour-glass. The composition ex-
presses a forceful, virile piety. The best of the paintings
on this theme are in the collection of the Marquis of
Santa María de Silvela in Madrid, the Hispanic Society

125 *St Ildefonsus* 1605–10

126　*St Ildefonsus* 1605–10

of New York, and in the National Gallery, Edinburgh.

A version of *St Jerome in Penitence* [132] shows the Saint full-length, one knee on the ground, in a posture recalling the *St Sebastian* of Palencia Cathedral and the Christ of the *Baptism*, his arms outstretched and his face lifted up towards the area of sky that is visible in one corner of the canvas.

Another new theme embarked on by El Greco at this period is *Christ in the House of Simon* [128]. One version has an architectural setting reminiscent of the *Purification of the Temple*; in a second, the action takes place within an entirely enclosed area, probably an actual location in Toledo. The apostles are seated in a circle around a table together with three women, one of whom, viewed from behind, is sumptuously clothed. In the centre of the composition is Jesus; a woman is anointing his head, and he is the only character who faces directly out from the picture.

The versions of *St John the Baptist* painted during this period illustrate how El Greco's art had developed from the early version for the altar of Santo Domingo towards the very elongated, spiritualized forms of the late works. The Saint stands like a trembling reed against the expanse of sky. His exaggerated height, and the skilful division of the canvas into two zones, make the Saint appear to belong both to heaven and earth. Among the finest works on this theme are those in the San Francisco Museum and the Koehler Collection in Berlin.

The *Laocoön* [133] in the National Gallery, Washington, is unique in El Greco's work. The discovery in Rome, in 1506, of the Hellenistic sculpture of *Laocoön*,

127 *The Assumption (Immaculate Conception) 1608–13*

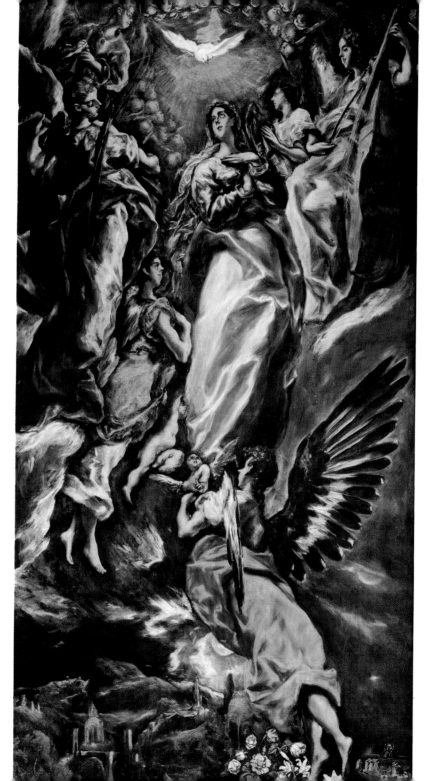

made a great impression on the artists of the time, on Michelangelo in particular, and it was copied quite extensively and provided the inspiration for many other works. One Spanish artist who made a copy of the sculpture was Berruguete. El Greco had read his Homer, and must have been familiar with the statues and engravings of the Greek world. With many different sources to draw on, he created a new, original version of the subject. The picture as it is now has recently been restored and displays the full beauty of the nude bodies; formerly these were covered with

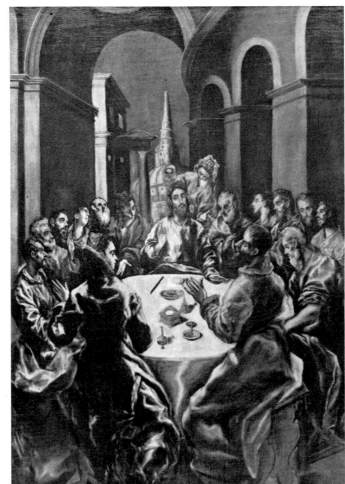

128 *Christ in the House of Simon* 1605–14

172

loincloths, in response to the wave of prudishness inspired by the Council of Trent, inevitably a powerful influence in a place like Toledo, a centre of High Catholicism and a home of the Inquisition. Curiously, the figures are not tightly grouped, as they are in so many other compositions, but each giant figure stands quite separately. The city of Troy in the background is in fact a faithful portrait of Toledo, and the Gate of Visagra, the Alcazar, the tower of Santo Tomé and several other monuments are clearly distinguishable. Nothing could be more anticlassical than this painting of classical inspiration. The nudes have neither the Realism of the Flemish painters nor the three-dimensionality of the Italians. They have an extraordinary quality of movement and waves of dark colour ripple through their bodies. This version was painted shortly before 1610. Two other versions are listed in Jorge Manuel's inventories, one of the same size, the other rather smaller. Both have vanished without trace.

Towards the end of 1607 El Greco was given the commission for an *Assumption* [127], sometimes titled an *Immaculate Conception*, for the retable of the Chapel of Oballe in the Church of San Vicente. The painting was to have been done by Alejandro Semino, but he had died; as a result we have an invaluable document in which El Greco lists his specifications and makes a number of points about his view of aesthetics. In the contract he stipulates that the new altar will be taller than that planned by Semino, by 'more than a fifth part of the whole work' so that it 'will not be dwarfish, the worst possible thing, whatever the form'. Started in 1608, the *Assumption* was finished on 16 April 1613, as

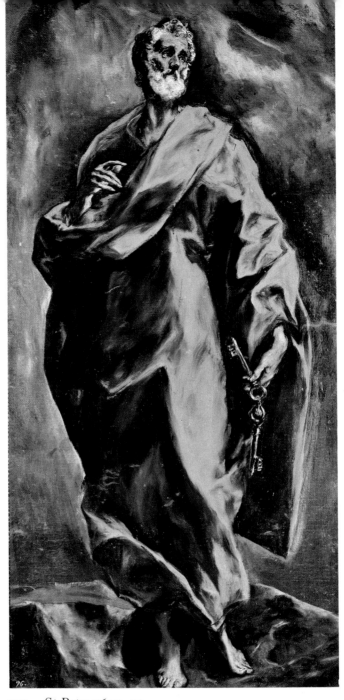

129 *St Peter* 1605–10

130 *St Sebastian* 1610–14

we know from a document written by El Greco and
published by Cossío. Completed only a few months
before his death, it is one of his last great works. The
composition takes its point of departure from the view
of the Toledan landscape and a bouquet of roses and
lilies, out of which emerges an angel with outspread
wings. The Virgin seems impelled upwards by the

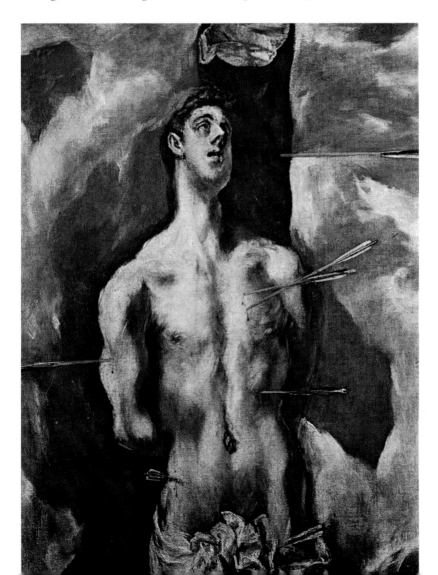

motion of the angel, and on either side of her are another two angels.

The *Visitation* painted for the Chapel of Oballe, and today in Dumbarton Oaks, Washington DC, was never completed and Aznar believes it was meant as a sketch for the final painting which was to decorate the ceiling of the Chapel of Oballe, which is mentioned in the contract for the commission. The two women face each other, virtually transfigured by the light; they are represented with an effect of foreshortening of rare monumentality, and are enveloped in cloaks so that their faces are scarcely visible.

The *Marriage of the Virgin*, now in Bucharest, is of uncertain date but must be one of El Greco's very last works, judging by the long figures with their flowing translucent robes, the cold, eerie colours, transparent greys and blues contrasting with dark shades of green, yellow and orange.

In *The Fifth Seal of the Apocalypse*, formerly in the Zuloaga Collection, the upper section has been cut off, which makes it difficult to interpret. As one sees the panel today in the Metropolitan Museum of Art, New York, it appears to represent, in the words of the second inventory, 'St John seeing the visions of the Apocalypse'. The Saint is a monumental figure filling the whole of the left-hand side of the canvas from top to bottom. He is kneeling, his arms stretched out towards the sky, in a state of ecstasy as he contemplates the scene above him (which is no longer there). In the distance behind him are two women and five men, all nude, bathed in a ghostly light and surrounded by lengths of cloth that glow with greens and yellows. The Bible

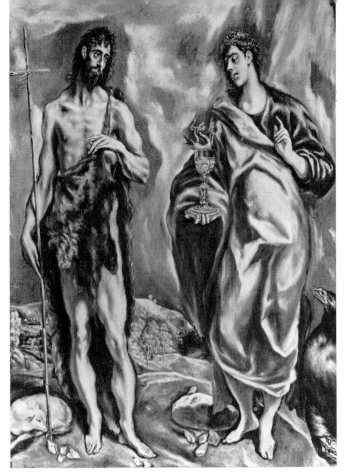

131　*St John the Evangelist and St John the Baptist*
1605–10

contains several passages comparing the heavens or the worlds of the Apocalypse with various kinds of cloth. Possibly the characters are intended to symbolize the Resurrection. Or, because of their number, they might equally be a reference to the seven visions. In the end it

132 *St Jerome in Penitence* 1612–14

is not all that important. *The Fifth Seal of the Apocalypse* and the *Laocoön* are perhaps El Greco's finest and most astoundingly original creations. There is a clear resemblance between the male nude on the far left of the *Laocoön* and the figure on the right in the *Apocalypse*. A comparison of the nudes in the two pictures shows how El Greco was developing as an artist in his final period. In the later picture his exaltation is tempered by the requirements of the men commissioning him, the increasing power of the Inquisition, and by the strict observance of the recommendations of the Council of Trent, also by the new mood of austerity in Spanish society, to which El Greco must have adapted himself only with difficulty.

Also presumed to be a work of his maturity is the *Pentecost* [123], now in the Prado. In Christian iconography the coming of the Holy Spirit is usually represented as an occasion of great rejoicing, but El Greco turns it into a scene of violent commotion, choosing to emphasize the uproar among the apostles and show the flames actually touching their heads. Once again he adopts a device he had used before, notably in the *Burial of the Count of Orgaz*, and grouped the characters' heads together along a continuous horizontal line. At the foot of the composition are the two prominent figures of St John as a young man and St Peter, who is reeling backwards with shock. There is no perspective, and surfaces and characters are placed vertically one above the other.

Apart from the small panel of *Mount Sinai*, painted in Italy, and the landscapes used as backgrounds to certain of the Toledan compositions, notably the

133 *Laocoön c.* 1609

Laocoön, El Greco painted only two landscapes, both
of these in the closing years of his life. They are impres-
sively modern and epitomize all that is most original
about his work.

The *View of Toledo* [136], now in the Metropolitan
Museum of Art, New York, is a brooding and phantas-
magorical landscape; the various monuments and sites

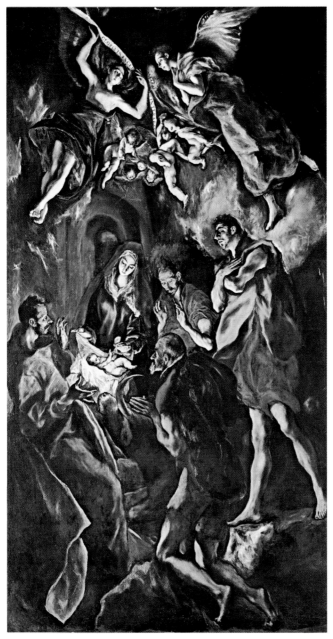

134 *Adoration of the Shepherds* 1612–14

are clearly recognizable but they are transformed into a ghostly and hallucinatory scene. The Tagus runs, intensely blue, through meadows of phosphorescent green, its banks are shadowy areas, the monuments are bathed in a pallid light that glows purplish-blue at the edges, the stormy sky is rent with lightning flashes and the horizon is black. This is the opposite pole of Realism, a visionary exaltation that transforms and transfigures elements borrowed from the real world.

The *View and Plan of Toledo* [137], in the Museo del Greco, employs a quite different range of colours; the pink, golden-tinted pale ochres, the soft bluey-greys, are suffused with the silver morning light. In the foreground, to the right, is a young man who has sometimes been identified with Jorge Manuel, unfolding a map of the town. The figure is indistinct. A subtle gradation of green tints makes his doublet merge into the surrounding landscape. The face itself, pale and almost featureless, is set against a fine ruff, painted to give an effect of transparency. The character on the left symbolizes the Tagus, and carries ears of grain, fruit and a pitcher of water. In the centre of the canvas appears the Hospital Tavera, which at the time of the painting had only just been built, and which would in fact have been seen from the rear when viewed from that position. The building is shown with its façade towards us and stands on a cloud, no doubt to make clear the artifice of its altered position. Spreading out into the distance is a bird's eye view of Toledo, in a striking gamut of greys, ochres and pale blues which give it an air of icy unreality; above, the intense pale blue of the sky has the same silvery highlights as the

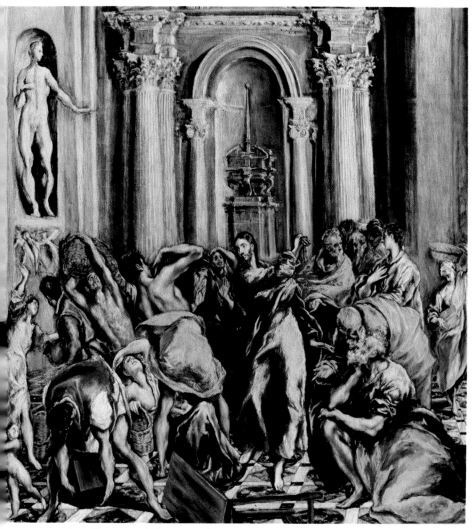

135 *Purification of the Temple* 1610–14

town. In the sky, at the top of the canvas, is the Virgin, surrounded by a whirlwind of angels: she is descending from heaven to give the chasuble to St Ildefonsus, the Archbishop of Toledo. This weightless and insubstan-

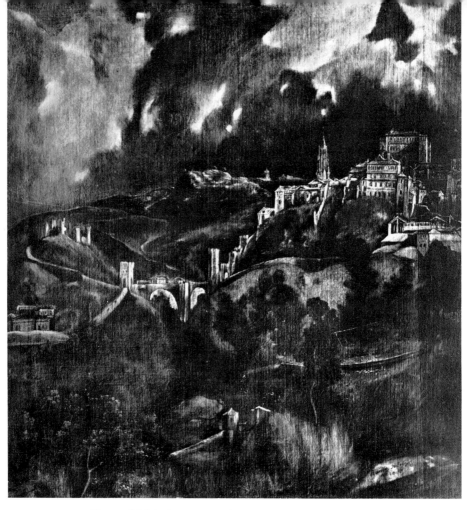

136 *View of Toledo* 1595–1610

tial group is painted in a range of cold tones, pearly whites and greys, contrasting with the yellow of the chasuble. In the inscription on the map of the town, El Greco explains why he thought it necessary to change the site of the Hospital of San Juan Bautista; he also explains that, for his representation of the Virgin, he availed himself of 'a certain manner of regarding

184

celestial bodies like lights which, seen from afar and however small they may be, seem large to us'.

In his last years El Greco executed a series of saints known as the *Apostolados*; there are several cycles, each conceived of as a separate unity. Nine that are more or less complete have been catalogued, and the best known are in Toledo Cathedral, the Museo del Greco in Toledo and in the collection of the Marquis of San Félix in Oviedo. The apostles are almost always represented as individual half-length figures, and each series is completed by a painting of the Saviour. The paintings of one cycle need to be seen all together in order to understand the underlying unity, the way they were conceived of as parts of a whole. The saints are shown as visionaries with a vocation, in a state of ecstasy, but they are obviously teachers as well, adopting an attitude of persuasive eloquence towards the men to whom they are to pass on their message. The *Apostolado* of Almadrones was discovered in an abandoned church during the Civil War; only eight pictures of the cycle have survived.

In each cycle, *The Saviour* [139] presiding over the apostles is shown with very little variation. Wearing a red robe and a green cloak, he raises his right hand in the Byzantine style of blessing, while his left is resting on the world. His handsome face with its big, gentle eyes is set against a diamond-shaped halo.

St John the Evangelist [141], one of the finest figures of all the *Apostolados*, is the first appearance of an iconographical type that was later taken up in sculptures and repeated in eighteenth-century works. The young Saint has a gaunt, elongated, clean-shaven face, and

holds a chalice in his right hand; with his long, tapering left hand he points to a dragon represented on the chalice. The drapery of the robes, as in the other paintings of the cycle, is of incomparable splendour.

St Peter, with his long bushy beard, has all the rough worth of a peasant. *St Andrew* [149] is a huge impressive figure, standing behind the cross that cuts right across the composition. *St Paul* [146] has the emaciated face of an ascetic. El Greco shows him holding in his left hand the *Epistle of St Paul to Titus*, the first Cretan bishop; the opening lines, in Greek script, are clearly

137 *View and Plan of Toledo* 1608–14

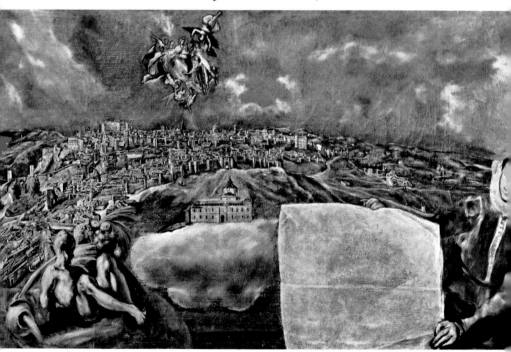

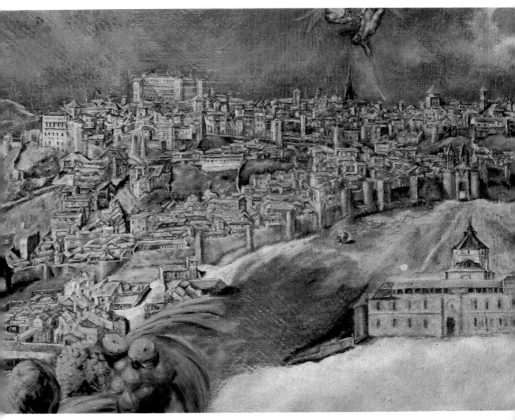

138 *View and Plan of Toledo* Detail

visible. In other versions, such as those in the Church
of San Vicente in Toledo and in the Prado, the Saint is
holding a book in his hands, or, as in the version in the
collection of the Marquis of Campo Real, he is resting
his hand on an open book. El Greco adopts an unusual
view of *St Luke* [147] and shows the Saint holding a
Book of Hours, modestly indicating the image of the
Virgin he has just finished painting. *St James the Less*
[148] and *St James the Greater* have faces of great intelli-
gence and nobility; each holds a huge book and gestures

187

with the other hand as though teaching a lesson. The finest examples are in Toledo Cathedral. Other versions represent them standing, holding a stick.

St Thaddeus is an old man with a humble yet fearful expression, resting on a pikestaff, the symbol of his martyrdom at the hands of the Persians. *St Thomas* is a tall figure, typical of El Greco's late works. *St Simon* [144], with an open book resting on his two hands, is the hermit avid for learning. *St Matthew* is shown writing his Gospel. *St Philip* is in profile, holding a cross in his left hand and raising his right hand in a dramatic gesture. The *St Bartholomew*, in the El Greco Museum in Toledo, is one of the most hallucinatory figures of

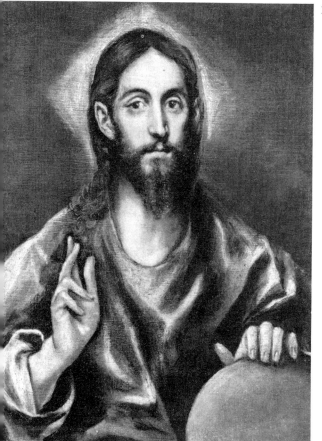

139 *The Saviour* 1605–14

140 *St Paul* 1605–14

141 *St John the Evangelist* 1605–14

142 *St Andrew* 1605–14

143 *St Luke* 1605–14

144 *St Simon* 1605–14

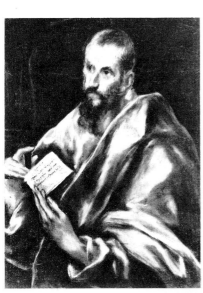
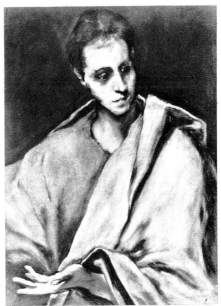
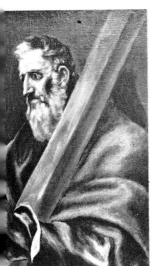
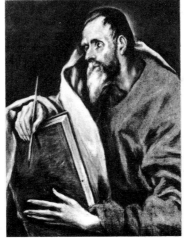
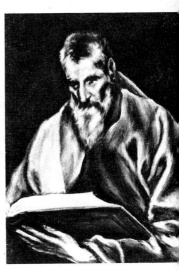

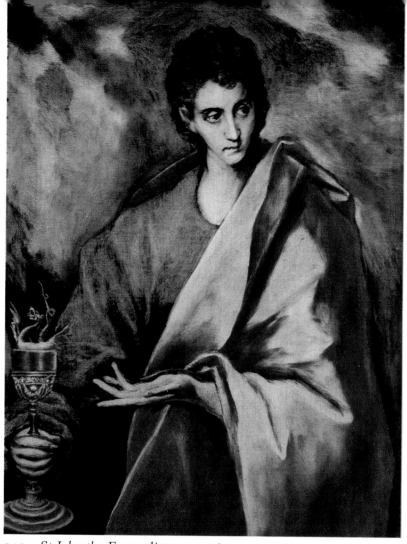

145 *St John the Evangelist* 1595–1604

the whole series of the *Apostolados*, so dematerialized that even colour would be out of place. The robe and cloak are of a shining white that enhances the cadaverous pallor of the face, in contrast with the black of the beard and hair. He leads a demon in chains.

190

There are many paintings by El Greco which certainly contain portraits of contemporary figures, even though the sitters' names are not known today; two of the most striking instances are the *hidalgos* and noblemen of the *Burial of the Count of Orgaz* and the *Madonna of Charity*. However El Greco did paint a large number of portraits where the model is identified, among them a self-portrait which, according to Giulio Clovio's letter to Cardinal Farnese, aroused the admiration of all the painters in Rome; this, unfortunately, has vanished without trace. The expressive power and

146 *St Paul* 1594–1607

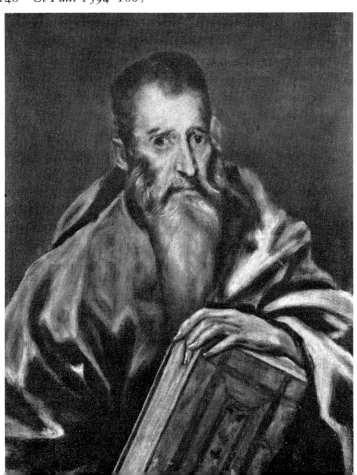

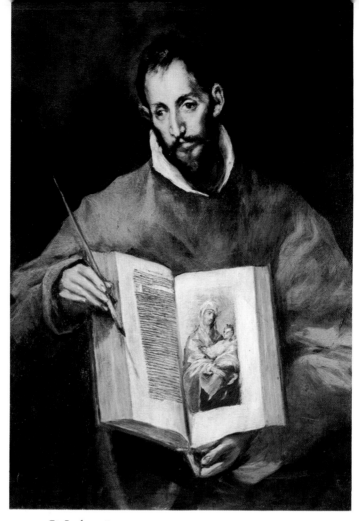

147 *St Luke* 1602–05

psychological penetration of all the religious characters
he represented, reveal El Greco's gift for portraiture,
his ability to convey the essential nature and soul of a
man. It is an interesting fact that his models did not
include the great personages of his day, and we may
suppose that most of his sitters were personal friends,

intellectuals like Giulio Clovio, his protector in Rome, Pompeio Leoni, the famous artist who probably gave him his introduction to court circles, the canon Antonio de Covarrubias, the Greek scholar who defended him

148 *St James the Less c.* 1600

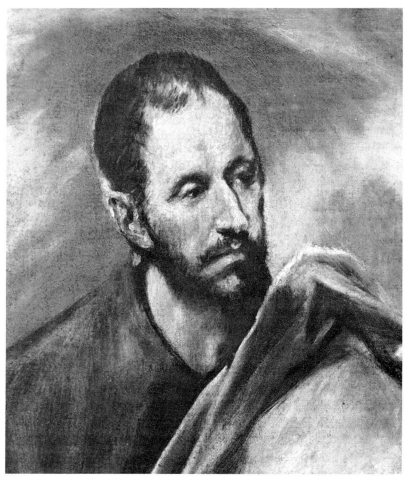

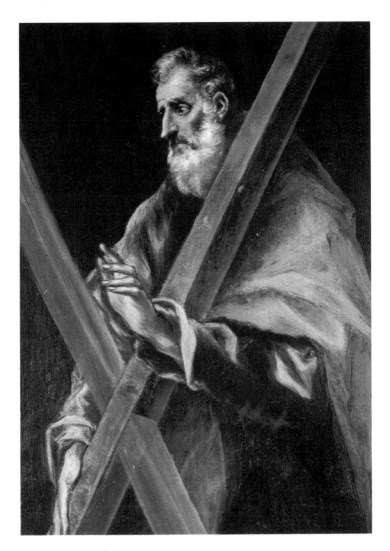

149 *St Andrew* 1602–05

against the Chapter of Toledo Cathedral, Don Diego
de Castilla, Bishop of Segovia and the most illustrious
Spanish jurist of the age, and Hortensio Félix de Para-

vicino, preacher and man of letters, who wrote four sonnets dedicated to El Greco.

The models whose identity is unknown, or in some doubt, include monks, ecclesiastics, a painter, a doctor and a poet – all cultivated men, scholars of literature or jurisprudence, people of distinction. The commissioned works include the portraits of three cardinals: Cardinal Tavera, who founded the Hospital of San Juan Bautista, Cardinal Niño de Guevara (for the Convent of San Pablo Ermitaño), and Cardinal Quiroga (for the Refugio in Toledo).

By the second half of the sixteenth century, the portrait painters of the Spanish court had absorbed the lessons of the Flemish school and applied them diligently to their works. The most famous of them was Sánchez Coello. The portraits of the school of Madrid, at the end of the reign of Philip II, reflected the austerity of the court; rich trimmings and jewels were still painted with great attention to detail, but the heads of the characters became the focus of interest, and the faces acquired a more spiritual expression, tinged with melancholy. They have a stereotyped quality which renders them timeless. The identities of the subjects are of little importance as they represent historical types, transcending their local or historical significance to become universal images of mankind.

In El Greco's work, technique reinforces this dimension of futurity. Alert to all the possibilities inherent in each attitude, in the play of the features, he can capture the moment of maximum expressive intensity. Unlike the portraits of the Renaissance, El Greco's figures are not fixed entities, they are in transition from their past

to their future, they reveal the hidden depths of their personalities, the contrast between the ephemeral nature of man and the ambitions and impulses within him. This is the duality of nature and mind of Cartesian man, the 'dark night of the soul' of St John of the Cross.

The portraits are in fact an even better guide to El Greco's spiritual development than the works with religious themes. In his religious paintings El Greco experimented with many different approaches, and late in life even returned to the principles that guided him in his youth. The portraits, on the other hand, show a steady evolution, from the Roman period, when they are still imbued with the Renaissance spirit, to the early Toledan works, and right up to the canvases painted at the very end of his life, in which all external details are omitted so that the subject's inner life becomes the focus of interest. The need to produce a likeness acted upon El Greco as a constraint, and he could not indulge in the distortions of his imaginative compositions. Their chronology is measured, not against 'a yardstick of elongation, but of increasing anguish', to quote the formula suggested by Camón Aznar. The frank, direct gaze of the early portraits gives way to more considered images, in which hints of bitterness or anguish are conveyed almost entirely by the hands and the expression in the eyes of the subject.

There are very few portraits of women. The *Lady with a Flower in her Hair*, in the Stirling Maxwell Collection, is a small, signed canvas of a young woman with a gracious air, wearing a black dress and a white hat, and a white lily in her hair. It has been suggested

that this is a portrait of Jorge Manuel's first wife. The portrait of an unknown woman, known as the *Lady in a Fur Wrap* [45] cannot be attributed to El Greco with any certainty, but has been regarded as a picture of Doña Jerónima de las Cuevas, El Greco's wife.

A fine example of El Greco's early Toledan manner is the *Portrait of a Young Gentleman* in the Château de Rohoncs Collection. It is very Spanish in character and the colouring is restrained: the big, black eyes look out beneath heavy brows, the face is framed by a ruff, and one strong, elegant hand is against the man's breast, standing out against the black of the habit.

The *Portrait of a Nobleman with Hand on Breast* [152] has become the prototype for the Spanish *hidalgo* of the sixteenth century. As in most of the male portraits, the face and hand emerge from the white ruff and white lace on the cuff, and are sharply defined against the neutral background and black doublet. The gesture of the hand, with the fingers spread but the second and third finger touching, is a familiar feature of El Greco's work, and closely resembles the attitude most often adopted in Byzantine murals and mosaics.

The *Portrait of an Elderly Gentleman* [150], in the Metropolitan Museum of Art, New York, was long regarded as a self-portrait of the artist, but there is no evidence to support this view. Big eyes, of infinite kindliness, look out from the drawn and anxious face. The whole canvas has an air of tragedy and sorrow.

Julián Romero de las Azañas and St Julian [74] (the Saint is sometimes described as St Theodore or St Louis) shows the kneeling figure of a nobleman, wearing the habit of the Order of St James, together with his patron

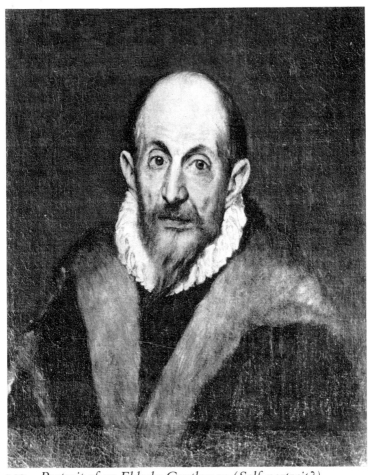

150 *Portrait of an Elderly Gentleman (Self-portrait?)*
1590–1600

saint, who is wearing a suit of armour. It is a rather
curious composition: both figures are looking upwards
in ecstasy, presumably at some heavenly vision. Per-
haps the original scheme was to include this vision, or
El Greco may have conceived the work in the form we
know it today but intended it to be placed by the side

of an altar, so that the characters in the picture would appear to be looking up at the altarpiece. There is a slightly funereal air about the whole painting, possibly because the knight's flowing white robes make him

151 *Portrait of a Gentleman* 1600–10

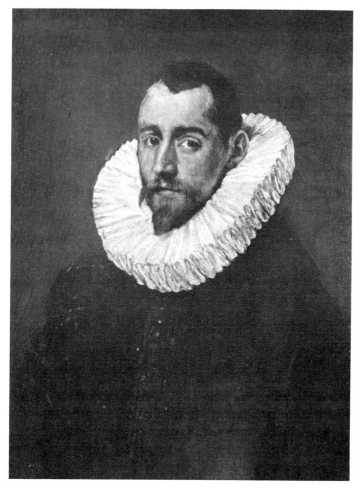

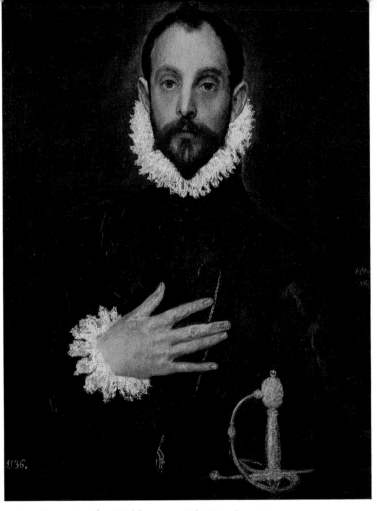

152 *Portrait of a Nobleman with Hand on Breast c.* 1580

look rather like a ghost. The suit of armour worn by the Saint is as elaborate as that worn by the Count in the *Burial of the Count of Orgaz*, which is contemporary with this picture. This is therefore a relatively early example of El Greco's practice of juxtaposing celestial and earthly figures in scenes of perfect naturalness.

The *Portrait of a Gentleman* [151] in the Prado is one of the most spiritually evocative pictures ever painted by El Greco. It is redolent with sadness and disenchantment, the gentle resignation of an intelligent man.

153 *Jerónimo de Cevallos* 1605–14

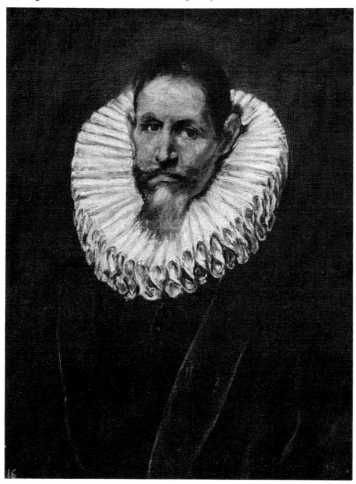

Jerónimo de Cevallos [153] was a government official of Toledo, a jurist and a man of letters. With Lope de Vega and other scholars, he used to attend the literary gatherings organized by the Conde de Mora. His portrait shows an intelligent, energetic man, with a rather melancholy expression. The magnificent ruff that frames the face contrasts with the dark green of the doublet. Its technique suggests that the picture was one of El Greco's late works.

It is likely that the *Portrait of an Artist* [154] in the Museum of Fine Arts, Seville, is a portrait of Jorge Manuel, and the picture is sometimes known simply as *Jorge Manuel Theotocopouli*. The head is youthful and manly, the expression on the face frank and direct. In his hand the artist holds a palette containing the five pigments that are the basis of El Greco's colour schemes: white, vermilion, red madder, yellow ochre and ivory black.

Fray Hortensio Félix de Paravicino [164] is one of the most famous portraits El Greco ever painted; it was referred to by Palomino and was discovered by Cossío in a private house in Madrid. Today it is in the Museum of Fine Arts, Boston. The young Trinitarian came from Madrid and was a fashionable preacher and poet, a friend of Góngora, Quevedo and Lope de Vega. His sermons and other writings were published after his death, including four sonnets dedicated to El Greco. The two men were close friends, and El Greco admired him greatly, probably appreciating the imagist flair of his oratory. It was through Paravicino that El Greco met Góngora, who wrote the famous sonnet that appears on his tomb. It is probable that Fray Hortensio

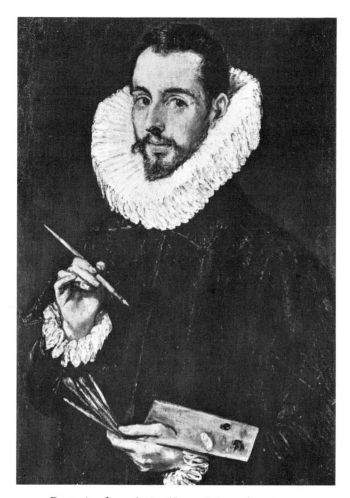

154 *Portrait of an Artist (Jorge Manuel)* 1600–05

was one of the guiding spirits of the intellectuals and artists of his day.

There is also a slightly earlier portrait of Paravicino, today in the collection of the Marquis of Casa Torres in Madrid, but it is little more than a preliminary sketch, showing only the head and shoulders, and at a different

angle from the Boston picture. It was this portrait, painted in 1609, that inspired Paravicino to write a sonnet expressing his admiration of El Greco's work. The more complete portrait was almost certainly painted in 1611, when Fray Hortensio went to Toledo to take part in the poetry contest held to mark the death of Queen Margarita. El Greco was asked to design the catafalque for the funeral, which was to be celebrated in the Cathedral, and this monument inspired another of the four sonnets written in his honour by Paravicino.

In the Boston picture the young orator is sitting peacefully in a chair, leaning against the arms, with one hand, marking the page in a half-open book that is supported on a big folio volume. Under his black habit he wears a white soutane, bearing the red and blue cross of the Trinitarians. Set against the white hood is the fine head with its thatch of hair and lively intelligent young face, with big black eyes and fleshy, sensual lips in a half-smile. The physical and mental power expressed in the portrait suggest something of the influence and respect the preacher must have enjoyed among his contemporaries.

The portrait in the collection of the Marquis of Casa Torres focuses all the attention on the head, remarkable for the romantic passion of the fevered expression and piercing, forthright gaze of the eyes.

We know of two portraits of *Don Antonio de Covarrubias*, one in the Museo del Greco in Toledo, [157] the other in the Louvre [156]. Covarrubias was a theologian, archaeologist, jurist, Greek scholar and historian – the perfect humanist. He attended the Council of Trent and was a member of the Royal Council of

Castille and, in 1580, became secular canon of Toledo Cathedral. El Greco must have been a friend of his and have had a considerable respect for him, for he appears to have used him as the model for several minor figures in various works, notably the *Burial of the Count of Orgaz*.

155 *Don Diego de Covarrubias 1600*

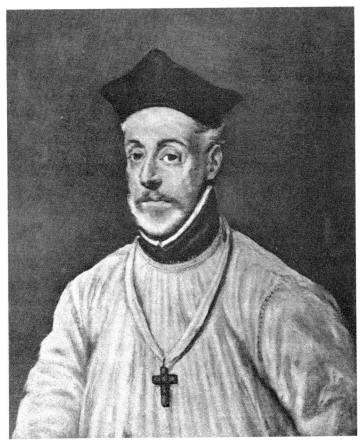

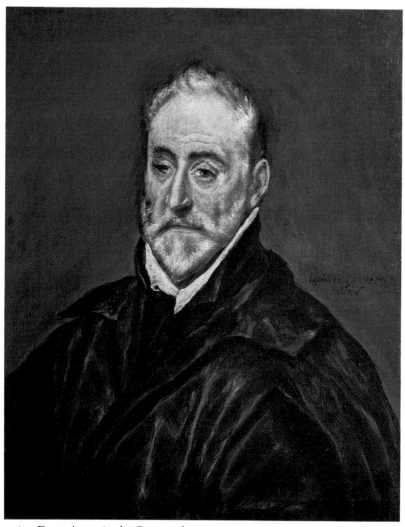

156 *Don Antonio de Covarrubias* 1600

The portrait in the Louvre, which is thought to be later than the one in Toledo, shows an old man full of pathos, his expression one of sorrow and anxiety and his smile subdued and ironical. The colouring is re-

strained, the blacks and whites being streaked with pink and purplish-blue. The version in the Museo del Greco is equally fine, although it lacks something of the spontaneity of the Louvre portrait.

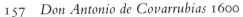

157　*Don Antonio de Covarrubias* 1600

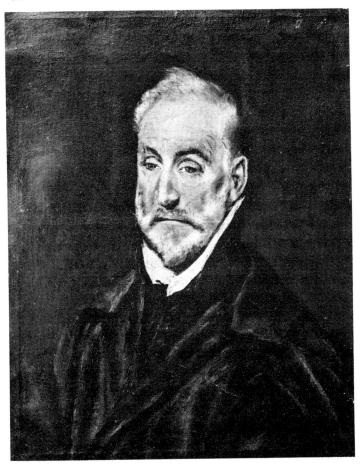

Roughly contemporary is a portrait of *Don Diego de Covarrubias*[155], Don Antonio's elder brother. He too was a great humanist, Professor of Canon Law at the age of twenty-two at the University of Salamanca, Bishop of Segovia, President of the Royal Council of Castille, and a delegate at the Council of Trent. The work employs the range of blacks and whites typical of the portraits painted in the early years of the sixteenth century. Streaks of carmine and violet heighten the whites and predominantly grey tones. It has been said that the coloured shadows and dissolving contours of this picture anticipate the discoveries of the Impressionists.

El Greco painted three portraits of cardinals, Don Gaspar de Quiroga, Don Fernando Niño de Guevara, and Cardinal Tavera. The handling of the portrait of *Cardinal Quiroga* is Titianesque and the subject is shown in profile, like a Renaissance prelate; there is an inscription bearing his name and explaining that he founded the Refugio in Toledo. The picture, now in a private collection in Munich, must have been painted after the death of the Cardinal in 1594.

Cardinal Fernando Niño de Guevara was Archbishop of Toledo and was created a cardinal in 1596. In 1601 he became Archbishop of Seville and Grand Inquisitor. As Inquisitor-General he visited Toledo in 1600, and it must have been on this occasion that El Greco painted the portrait, today in the Metropolitan Museum of Art, New York. The Cardinal is shown dressed in his red robes and seated in a chair.

The infinite gamut of shimmering reds in his vestments most probably inspired Velasquez when he

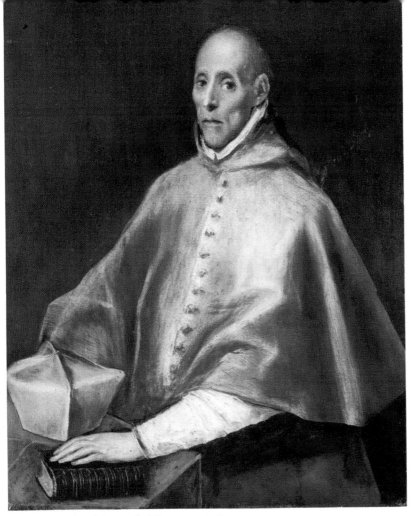

158 *Cardinal Juan de Tavera* 1608–14

painted his portrait of Pope Innocent X. The head
expresses energy, the expression is severe and penetrat-
ing, and of extraordinary intensity. This is rightly
regarded as the most powerful of all El Greco's por-
traits, both by reason of the sober restraint of the decor
and in its spirit of majestic grandeur.

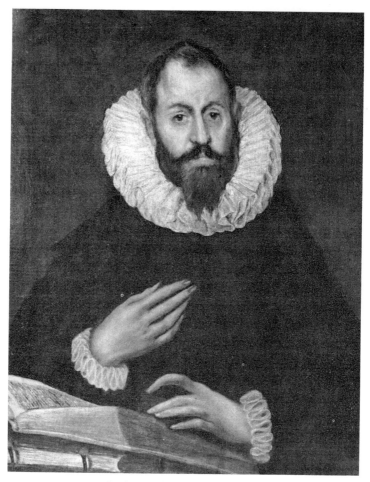

159　*Portrait of Alonso de Herrera* 1595–1605

Cardinal Juan de Tavera [158], who died in 1545, founded the Hospital of San Juan Bautista, for which El Greco was commissioned to design the retables. El Greco must have painted this portrait from the death mask, which is attributed to Berruguete and which, like the portrait, can still be seen in the hospital. Juan

de Tavera was Rector of the University of Salamanca, Archbishop of Santiago de Compostela, Seville and Toledo, Grand Inquisitor, President of the Royal Council of Castille, and Cardinal and Councillor to Charles V. Above the carmine red of the cape, the cadaverous head stands out from the black background. The left hand rests on a book next to the biretta. The

160　*Cardinal Fernando Niño de Guevara* 1596–1600

face is of ghostly pallor, and the picture is bathed in a glacial light that makes the figure look like a hallucination or an other-worldly apparition. The portrait is probably among El Greco's last works.

El Greco also painted a few portrait miniatures. Two, that are in the collection of the Hispanic Society, New York, are in an oval format and painted on paper; one represents a man, the other a woman. El Greco obviously enjoyed using small formats, witness the number of miniature paintings in his larger compositions. There are for example the *Stoning of St Stephen* and the *Trinity* painted on the Saint's dalmatic in the *Burial of the Count of Orgaz*; the images of St Paul, St Catherine and an apostle on St Augustine's dalmatic in the same picture; and the miniatures decorating the books in the portrait of *Giulio Clovio* and the *St Luke* in Toledo Cathedral.

Architect and Sculptor

The inventories of El Greco's library reveal the extent of the painter's interest in architecture. The second in particular lists the titles and authors of all the architectural books, mostly contemporary works published in Italy or Spain while El Greco was living in Toledo. There are four editions of Vitruvius, a copy of Vignola's *Rule of the Five Orders*, of 1593, and a 1583 edition of his treatise on perspective. The editions of Palladio must have been those published in Venice in 1570 or 1581, as the first Spanish translation was not until 1625. Reference is also made to five manuscript books in El Greco's own hand, one illustrated. Unfortunately these are no longer in existence.

For a long time a number of buildings were attributed to El Greco, among them Santo Domingo el Antiguo, the Hospital de la Caridad in Illescas, and the Casa del Ayuntamiento in Toledo. It is now almost certain that the identities of the architects of the first two of these buildings are known, and documentary evidence has recently come to light proving that Herrera was responsible for the Ayuntamiento. There is therefore no means of knowing whether there are any buildings in existence that were designed by El Greco.

There is however, evidence that he was responsible for either the actual construction or the design of the retables in which his paintings were contained, and, even though most of these retables no longer exist, it

is certain that he designed those for Santo Domingo el Antiguo, which are distinctively Venetian in style and may have been inspired by Titian's altarpiece for Santa Maria Formosa in Venice.

The altars and façades of this period were still strongly influenced by the Spanish Plateresque style, which was richly ornate and purely decorative in character. As Herrera broke with the traditional style in his buildings, so El Greco abandoned the elaborate reliefs of traditional architecture in his retables, substituting structures of classical restraint, with columns and pilasters, that formed plain settings to display his paintings to advantage. Another innovation was that he used canvases instead of the panels usual at that time.

The *Espolio* and the *Burial of the Count of Orgaz* were originally contained in retables, but as these have disappeared, along with the altarpieces for the Colegio de Doña María de Aragón, any assessment of El Greco's development as an architect has to rely solely on the retables in the Chapel of San José in Toledo (1597–99) and in the Hospital de la Caridad, Illescas (1603–05).

These are smaller than those intended for Santo Domingo and include fewer sculptures. Generally more robust in conception, they make use of strongly contrasted architectural details to accentuate the chiaroscuro of the relief. The retable for the Chapel of San José is crowned by an attic storey with a pediment which contains a painting. The sides are framed by projecting Corinthian columns and the entablature is supported on consoles.

This bold contrast is even more pronounced in the retables for the Hospital de la Caridad in Illescas: the

161 *Virgin Handing the Chasuble to St Ildefonsus* 1585

various architectural elements, columns and pediments are in high relief, and the whole is conceived of as a structure in depth. For the first time El Greco used Corinthian columns in groups of three, the shafts, capitals and entablatures treated separately. The whole has a marked effect of chiaroscuro. The ensemble is crowned by a frontispiece containing a painting, and is topped by a triangular pediment.

Dating from the final period is the retable for the Hospital Tavera, probably designed by El Greco but considerably modified after his death by his son Jorge Manuel, who must have adapted the original plan, intended for a flat surface, to the curvature of the apse. It consists of two storeys of tall Corinthian columns,

in the characteristic style of the High Renaissance. There are niches for sculptures between the side columns, betraying the influence of Herrera, and the whole is crowned by a rectangular canvas and a central panel encased in a strong frame.

From the inventories it is known that El Greco used to make figurines, or statuettes, of clay, plaster and wax, which, according to Pachecho, served as models for the composition of his paintings.

El Greco's sculptures are few and are in any case of doubtful attribution. The earliest were intended for Santo Domingo el Antiguo. Although the three Virtues are almost certainly the work of Juan Bautista Monegro, the two prophets crowning the central section may be by El Greco, their expressive attitudes and marked spirituality are certainly characteristic of his work. Both sculptures are gilded.

A relief of 1585, which represents the Virgin handing the chasuble to St Ildefonsus, was discovered by Cossío in 1901. Originally it formed part of the retable that contained the *Espolio*. The attribution to El Greco may be justified, as the relief corresponds to the detailed description of the altar made by Cardinal Sandoval y Rojas when he visited the Cathedral in 1601. The Virgin is standing and the Saint is kneeling by her side, his head turned towards her in a particularly graceful attitude. Angels with bare torsos and floating cloaks frame the oval composition. The relief was originally gilded but has since been crudely painted.

Commissioned in 1595 and completed in 1598, the *Risen Christ* in the Hospital Tavera is El Greco's finest sculpture. It was badly damaged during the Civil War

162, 163 *Epimetheus as Adam* 1567–69 *Pandora as Eve* 1567–69

and has had to be completely restored. It is reminiscent of the Christ in the paintings of the *Resurrection* but it is less heavy and has a stronger feel of upward motion, and the figure is of such smoothness that the light glides freely over the surfaces. Christ is shown in a walking attitude and, paradoxically, the naturalness of his pose enhances the impression of insubstantiality.

The retable for the Hospital de la Caridad, Illescas, contains two female figures, *Hope* and *Faith*, sub-

217

jects already represented in the Santo Domingo altar but conceived of here in a radically different way. In Toledo the two Virtues are shown standing in an attitude of repose, traditional heroic figures. In the Illescas versions they are kneeling on acroteria in much more realistic attitudes, their garments are more natural than classical, a swirling contrast of angles and planes. Like the Toledo statues, they are gilded.

In the lateral niches are life-size representations of the prophets Simon and Isaiah, the first in a hieratic attitude, wearing mitre and soutane, alb and chasuble; these elements are realistically handled.

The Illescas retable is completed by two nude angels shown seated on the cornice. Whether these are by El Greco is less certain, as the commission was entrusted to 'Domingo Griego y Jorge Manuel pintores', making it likely that the son was responsible for at least some of the sculptures, which are very uneven in quality.

The Conde de las Infantas owns two fine nudes in wood of a man and a woman; they are $16\frac{1}{2}$ inches high, the anatomy is rounded and detailed, and the surfaces are boldly modelled. They are reminiscent of the *Adam and Eve* in the *Modena Triptych* and of certain figures in the *St Maurice*, the *Laocoön* and the *Apocalypse*. The obvious parallels would be with the work of Sansovino or Benvenuto Cellini. The woman, who has a gem encrusted on her forehead, could be Venus; if so, the man, who has a Greek-style pitcher in his hand, would be Vulcan, her husband. Following the Byzantine practice, the male figure is painted in darker colours than the woman. It is possible that these sculptures date from El Greco's Venetian period.

The Toledan Spirit: The Influence of El Greco

Because a great painter tends to cast the achievements of his disciples into the shade, it is all too easy to assume that he was an isolated figure of genius who had a negligible influence on his successors. This is rarely true, and certainly is not true of El Greco. It is only just beginning to be recognized that, however exceptional his own contribution, his direct influence was much more extensive than was previously imagined. Although he left Toledo very rarely, his major works had a reputation that spread well beyond the province; into his orbit came many great artists, representing or associated with many different schools. These contacts were so numerous that one can justly speak of, not a Toledan school perhaps, but certainly a Toledan spirit or approach that influenced Spanish painting at the start of the seventeenth century.

Luis Tristán is the best known of El Greco's disciples. He worked under him from 1603 to 1607, possibly longer, and left a large body of work even though he died young, in 1624. He was faithful to the themes favoured by his master but tended to simplify his compositions and reduce the lyrical exaggeration of the forms to the proportions of real life. This different vision imparted to his pictures, even when the constituent elements were in other respects unchanged, a quality of Popular Realism that was extremely rare at that time. His muted range of colours, lacking the airy

transparency of El Greco's palette, emphasize his return to everyday reality. In his cold, painstaking portraits Tristán concentrates on the facial mask, creating austere, withdrawn effigies. There was an ancient tradition that linked Tristán with the young Velasquez, although this is now disputed. But even if there was no direct influence, the legend contains a germ of truth, for the Sevillians were deeply curious to know about the work of El Greco and his successors, as is demonstrated by the number of works by Toledan painters that they bought and by Pachecho's pilgrimage to El Greco's studio.

It was Pedro Orrente who supplied the link between Toledo and the various schools of the Levant. He was born in Murcia in approximately 1570 and painted in Valencia before going to Toledo. There he worked with El Greco and became his friend; later he acted as godfather to one of Jorge Manuel's daughters. He went back frequently to his native province and undertook numerous commissions there, enjoying a reputation that at times equalled that of Ribalta. He had several pupils, the best of them a painter called Esteban March of considerable inspiration, although unfortunately this was expressed in an awkward blend of styles. Orrente never lost sight of the grounding in Tenebrism he had acquired during his early days in Valencia, and employed a sombre range of muted colours for his rustic scenes, which were painted with a strong sense of Realism. The bold modelling of his designs anticipated even Ribera, and his compositions were conceived of in terms of stark, simplified three-dimensional masses. It is this above all that distinguishes him from Bassano, with whom he is often compared because of

the similarity of their themes. Orrente had no interest in the iridescent and scintillating colours favoured by the Italians, and concentrated on a limited range of austere and neutral tones which focused all the attention on the subject matter; each detail has an autonomous existence and is given its full weight and value. It should also be remembered that, when Orrente was summoned to Córdoba and Seville, his work was much copied and admired, in particular by Antonio del Castillo.

This tendency to lay stress on the human significance of sacred themes was to be observed simultaneously in Valencia, with Ribalta, in Toledo, in the aftermath of El Greco, and in Seville, in the early works of Velasquez and Zurbarán. At this period Ribera's pictures had not penetrated into Spain, and Italian influences, where these existed, seem to have stopped short of Caravaggio. Fray Juan Bautista Maino, who was born near Milan but entered the Dominican monastery of San Pedro Mártir in Toledo some time before 1608, is closer to the spirit of Orazio Gentileschi. His work is often indulgent and betrays a lack of judgment, and he enlivens his canvases with such gaudy contrasts of colours that he had no need to use effects of light and shade. Yet in as far as his composition and spirited drawing is concerned he is closely linked with Tristán, and his portraits too have the austerity of Tristán's works of this type. Later he attempted, much in the same vein as Pachecho although with greater spontaneity, to depict scenes of contemporary history, and to set them against natural-looking background landscapes. He viewed the scene of the *Retaking of the Bay*

of S. Salvador in terms of its human significance, and intervened in the picture to emphasize the importance of an event that touched him personally. In Madrid, Vicente Carducho, a Florentine who had studied in Valencia, was still largely under the influence of Tintoretto. And the great Venetian painters were still the main source of inspiration for Ruelas, who, as has been brilliantly demonstrated by A. L. Mayer, was responsible, far more than Herrera the Elder, for liberating Sevillian painting from the uninspired copying of the techniques of Mannerism. Juan de las Ruelas, or Juan de Ruela, spent some time in Italy from 1606 to 1609, probably in Venice and Parma. After his return to Spain he spent the next few years filling the churches and the Cathedral of Seville with a series of colossal works, of Michelangelesque proportions; these are expressive of all the liveliness and vitality seen in the great Venetian decorations, and in this they anticipate Rubens himself. Ruelas has a fine technique, using warm harmonious colours and an easy flowing line. This splendid painter had many pupils, among them Varela and Juan del Castillo, the painter who encouraged the emergent talent of Alonso Cano and also taught Murillo.

The most interesting of all these painters is Cotán. Long regarded as a minor artist, he nevertheless anticipated the ability demonstrated by Velasquez, Zurbarán and even Murillo, in their early days, of capturing a mood of harsh, undiluted reality, free of all trivializing details that would detract from perfect or idealized beauty. Juan Sánchez Cotán was born in Orgaz, La Mancha, in 1561, and studied under Blas del Prado in

Toledo. He started as a painter of *bodegones*. These kitchen scenes of vegetables, fruit and poultry, which were beginning to enjoy international popularity, were to acquire in Spain, thanks to Cotán, a completely new style and emphasis. Instead of trying to group or juxtapose objects in such a way as to make them look as interesting or appealing as possible, Cotán separated out the different elements of his picture, isolating each object in its own area of space so that it was the most intense expression of itself. He gave a new dignity to the humblest of themes and a quality of density to immobile objects. He took holy orders late in life, in 1604, and entered the Carthusian monastery of Paular. He appeared again in 1612 in Granada. There he continued his earlier work on much the same lines, but also embarked on a series of equally fine religious paintings of shattering and pointed simplicity, representing the most significant episodes in the history of his Order, the resolution of martyrs suffering persecution. In his great composition of *English Carthusians before their Judges*, a curtain is parted to reveal one of those peaceful architectural backgrounds, bathed in calm white light, that were later to be a characteristic feature of Zurbarán's paintings. Towards the end of his life Cotán spent a great deal of time with the painters in Seville, Ruelas in particular. He died in Granada in 1627. During this transition period, when the overall tendency in painting was towards theatricality, Cotán's work displays a unique homogeneity and purity.

So Toledo can with reason be regarded as the meeting-point of new ideas and permanent values, a source of powerful and wide-spreading influences, the place

where, at the beginning of the seventeenth century, the common denominator of Spanish painting was decided. This common denominator was a sober and restrained Realism in which the subject matter was translated onto canvas with painstaking technical skill, and represented without superficiality, without sentimentality, and without triviality. Later, artists expressed themselves by means of the play of light and shade, the contrast between understatement and emphasis, but at this time they still used a palette which was itself subservient to the demands of the subject and was calculated to represent it faithfully and without distortion. Hence the predominantly neutral tones, the bistres, chestnut browns and greys – the colours of Cubism in fact. These were the most exciting new developments in Spanish art at the time when Velasquez and Zurbarán were beginning to paint, and these were the elements they had at their disposal. Spain was isolated from the rest of Europe. The few Italian influences that had made themselves felt belonged to a view of aesthetics no longer current, and they were soon totally forgotten in the enthusiasm for this new interest in reality.

It was the cosmopolitan genius of El Greco that gave Spanish painting its own set of values and pointed the way to future greatness.

El Greco and his Contemporaries

El Greco was a great lover of ideas and discussion, and submitted himself to bouts of self-analysis. His relationships with some of the finest minds in Toledo were anything but one-sided. He often painted his friends' portraits and, in addition, his unusual personality, his enquiring mind, and his paintings, gave them endless scope for thought. This is why contemporary accounts of El Greco and his work are so often distinguished texts in their own right. Put together as they are in this chapter, one can chart the reactions of his contemporaries to El Greco as a man as well as a painter.

Even as a youth, in Italy, El Greco aroused interest and admiration. Ronchini published in 1865 the text of the letter written by Giulio Clovio to Cardinal Farnese to introduce and recommend to him his young colleague. A famous miniaturist of Croatian origin, Clovio had spent many years in the service of the great Venetian family, the Grimanis, before he entered the employment of Cardinal Farnese. He had worked in Rome with the engraver Giulio Romano, and the principal manuscripts illustrated by him (*The Divine Comedy*, *The Lives of the Dukes of Urbino*, the *Breviary* in the Vatican Library) show a strong debt to Michelangelo. He achieved considerable fame as an illuminator and was in fact called the 'Michelangelo writ small'. His letter to Cardinal Farnese is a rare example of artistic generosity, and deserves to be quoted in full.

'To Cardinal Farnese in Viterbo.

There has just arrived in Rome a young Candiote, pupil of Titian, who in my judgment ranks among the finest of painters. Among other things he has done a portrait of himself which has amazed all the painters of Rome. I should like to place him under the shadow of Your Excellency, no other expenses of his living being required except a room in the Farnese Palace for a short time until he succeeds in finding better quarters. Therefore I pray and entreat you to have the kindness to write to Ludovico, the steward of your household, that he may provide him with some room in the upper part of the palace. Your Excellency would thus be doing a virtuous deed, one that is worthy of you, and I shall be obliged to you for it. I kiss your hands with reverence, the most humble servant of Your Most Illustrious and Most Reverend Lordship

Don Giulio Clovio'

On the other side, there is an account written by Giulio Cesare Mancini sometime between 1614 and 1619; it was published by Roberto Longhi in 1914.

'. . . Under the pontificate of Pius V, of holy memory, there came to Rome the man known as the Greek. Having worked in Venice, studying the works of Titian in particular, he had attained a great mastery of his craft. He came from Venice to Rome at a time when painters were not in great abundance, and did not display in their works the resolution and freshness that characterized his own. His zeal increased even more, encouraged by commissions, among which one may single out the picture today in the possession of the lawyer Lancilotti,

and which some believe to be a Titian. This was the time when the nudities of Michelangelo's *Last Judgment* were being covered up, because the Pope thought them indecent. He made so bold as to say that, if the whole work were destroyed, he would undertake to recreate it with honour and decorum and the painting would be no less good.

'These words aroused the indignation of all painters and art patrons; and he was obliged to depart for Spain where, under Philip II, he painted many works in excellent taste. But on the arrival of Pellegrino from Bologna, Federico Zuccaro and various Flemish artists, who were of the first rank in terms of art and skill, he determined to leave the court and retire to Toledo, where he died at an advanced age having almost ceased to practise his art. In the last analysis, this was a man who could be included, in the vigorous flowering of the age, among the best painters of the century.'

We can trace El Greco's activities in Toledo through contemporary writings that referred to his principal works almost as soon as they appeared. He painted the *St Maurice* for the Escorial in 1580 and received the payment in 1583, but the picture was not displayed as intended. In his *History of the Jeronymite Order*, published in 1600–03, Fray José de Sigüenza explained the circumstances of this affair.

'. . . Of a certain Domenico Greco, alive today and doing excellent works in Toledo, there has remained here a picture of St Maurice and his soldiers, painted for the altar of that Saint. It did not please His Majesty, which is natural enough as it pleases few people, although it is said to be of great merit, and that its author

is very skilful and that excellent things have been seen by his hand. As to that, there are many different opinions and tastes. To me, it seems that the difference between things created with reason and art and those that are not, is that the former appeal to everyone and the latter only to a few. For art merely reflects reason and nature, which are imprinted in every soul in perfect harmony. A thing that is badly done may, by some surface appearance or some glaze, deceive the senses of the ignorant, so pleasing the ignorant and those who do not pause for thought. After all, as our 'dumb' painter (Juan Fernández Navarrete, called 'the Dumb') used to say, one should paint the saints in such a way that they do not cease to make us want to pray to them, but rather inspire devotion in us, for that should be the principal effect and aim of painting.'

The *Burial of the Count of Orgaz* was painted in 1586. In his history of Toledo of 1612, Francisco de Pisa wrote an account of the painting.

'. . . the painting was executed, one of the finest in Spain. Foreigners came and viewed it with particular admiration; and the Toledans, far from growing tired of it, continually found that it contained new things to look at. Indeed it contains portraits from life of many illustrious men of our day. The author was the painter Domingo de Theotocópuli, of Greek nationality.'

Yet these factual accounts, even though they recognize the significance of El Greco's work and attempt to make some assessment of it, are by no means indicative of the seriousness with which he was regarded.

The two most important treatises on painting in the history of Spanish art contain information about El

228

Greco which casts a revealing light on the position he occupied after his arrival in Spain. Francisco Pachecho, the great Andalusian Mannerist painter, in whose studio in Seville Velasquez received his early training, went to visit El Greco in Toledo in 1611. He asked him a series of extremely pertinent questions and used his replies as the basis for a memorable page in his great treatise *El Arte de la Pintura*, written between 1632 and 1638 and published in 1649. This is an impressively comprehensive account of contemporary ideas on painting techniques, religious iconography and aesthetics. But its main value lies in the fact that it is (like the same author's *Libro de verdaderos retratos*, which deals with the illustrious personages of Seville) based on information obtained at first hand, making Pachecho the true precursor of modern techniques of interviewing great artists.

The following is Pachecho's account:

'Many of the "bravura" painters have cared little for beauty and a pleasing manner, laying stress instead on the quality of "relief" – men such as Jacopo Bassano, Michelangelo, Caravaggio and our own Jusepe de Ribera. We may also include Domenico Greco; for although we have often differed with certain of his opinions and paradoxes, we cannot exclude him from the number of great painters, for we have seen some things by his hand of such vigour and life (in his own distinctive fashion) that they must rank with the works of the greatest.

'The ancients are not alone in being scholars. In our century too there have been men learned not only in painting but also in the humanities. There was Michel-

angelo, whose many verse compositions we can read, and Leonardo da Vinci, Bronzino, Giorgio Vasari; and there was Domenico Greco, a great philosopher, shrewd in his insights, who also wrote on the subject of painting.

'In 1611 Domenico Greco showed me a cupboard filled entirely with clay models which he made himself to use in his work, and – a fact which is beyond all admiration – the originals of all his paintings, done in oils in a smaller format, all together in a big room which he directed his son to show me.

'Who would believe that Domenico Greco went back over his works many times and retouched them in order to keep the colours separate and distinct and give them that look of violent brushwork, so that they appeared full of vigour?

'I was most surprised on asking El Greco in 1611 which was the more difficult, drawing or colouring, when he answered colouring. Even more astonishing was to hear him speak with so little respect of Michelangelo, the Father of Painting, saying that he was a good man but could not paint. Yet those who know him well will not be surprised to see him differing from the opinion generally held among artists, for he had his own ideas about painting as he had about everything else.'

On the other hand Jusepe Martínez wrote the following in his *Discursos practicables del nobilísimo arte de la pintura* of 1673:

'At this same time there arrived from Italy a painter called Domenico Greco; it is said he was a disciple of Titian. He established himself in the ancient and illus-

trious city of Toledo; there he demonstrated his manner of such extravagance that it has never been equalled for sheer arbitrariness; the subtlest connoisseurs would find his extravagance hard to conceive of, for there was such disparity between his works that they did not all appear to be by the same hand. He arrived in the town with a great reputation, and indeed let it be known that there was nothing in the world superior to his paintings. And, in truth, some are worthy of the highest praise and place him among the ranks of the greatest painters. His character was as extravagant as his painting. No contract for any of his works has ever been heard of for, in his view, no price placed on them could be adequate.

'He earned a great deal of money, but spent it on maintaining his household in excessive luxury, to the point that he hired musicians in order that he might experience all manner of delights while he dined. He was very prolific and left as many as two hundred pictures started by himself. He was a famous architect and a very eloquent speaker. He had few disciples as they were unwilling to follow his teachings, so arbitrary and extravagant that they were suited to no one but himself.'

Most remarkable of all was that El Greco was also an inspiration to the poets of his time. First to Paravicino, the great orator who was official preacher at the court and who earned the praise of Lope de Vega and Quevedo; and later to Luis de Góngora, the celebrated Baroque poet who created a new language in his compositions. Such an exchange did not occur again until the time of Baudelaire and Mallarmé.

The following is a sonnet written by Góngora for El Greco's tomb.

Inscripción Para el Sepulcro de Domínico Greco

*Esta en forma elegante, oh peregrino
de pórfidio luciente dura llave
el pincel hiega al mundo más süave,
que dió espíritu a lēno, vida a lino.*

*Su nombre, aun de mayor aliento dino
que en los clarines de la Fama cabe,
el campo ilustra de ese mármol grave:
venerale, y prosigue tu camino.*

*Yace el Griego. Heredó Naturaleza
arte, y el Arte estudio, Iris colores,
Febo luces si no sombras Morfeo.*

*Tanta urna a pesar de su dureza
lágrimas beba y cuantos suda olores
corteza funeral de árbol sabeo.*

'Pilgrim! The elegant form of this hard stone of shining porphyry denies to the world the softest brush that ever gave soul to panel or life to canvas. His name, which deserves much wider fame than echoes now in the trumpets of renown, dignifies this sober slab of marble. Honour it, then go on your way. Here lies the Greek. In him Nature inherited Art and Art inherited Study, Iris gained colour and Phoebus light, but the shades of Morpheus were not increased. May tears crack this hard urn so that it exudes as many perfumes as the funereal bark of the Sabaean tree.'

Although Góngora is the more famous, I personally feel that Paravicino's sonnets are of greater beauty and significance. Through the fashionable hyperbole one can glimpse the poet's deep appreciation of El Greco's works; and their poetic conciseness permits the author to express many of his insights in particularly memor-

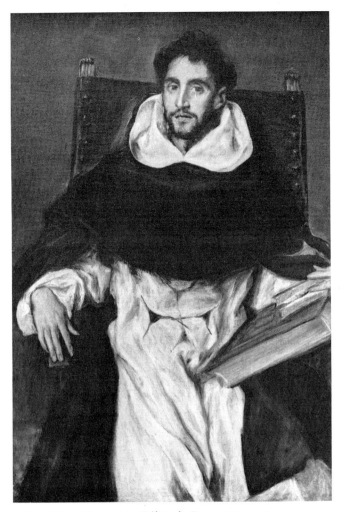

164 *Fray Hortensio Félix de Paravicino* 1609

able phrases – as for example when he writes, of El Greco's colours, 'I saw the snow on fire'. The very idea of this ray of light, this 'lightning flash' penetrating the painter's studio, is a sublime poetic invention. Four of his sonnets are reproduced here.

*Huésped curioso a quien la pompa admira
deste aparato Real milagro Griego
no lúgubres exequias juzgues ciego,
ni mármol fiel en venerable pira.*

*El Sol que Margarita estable mira
le arrancó del fatal desasosiego
desta vana región, y en puro fuego
vibrantes luces a su rostro aspira.*

*Al nacar que vistió cándido, pone
Toledo agradecido, por valiente
mano de Creta, caxa peregrina.*

*Tosca piedra la máquina compone,
que ya su grande Margarita ausente
no le ha quedado en España piedra fina.*

On the tomb designed by the Greek at Toledo for the funeral of Queen Margarita: 'Visitor, you who come out of curiosity to admire this display of regal pomp, this Greek miracle, do not judge blindly this mournful burial scene nor the faithful marble of this revered altar. The sun that looks down on this fixed image of Margarita tore her away from the fatal uncertainty of this vain place, and now breathes vibrant rays of pure flame into her face. The candid pearl in which grateful Toledo has encased her, by the Cretan's valiant hand, is become a rare casket. This cenotaph is nothing but rude stone for the great Margarita is gone and there is no precious stone left in Spain.'

Al mismo griego en un retrato que hizo del autor

*Divino Griego, de tu obrar no admira
que en la Imagen exceda a el ser el Arte;*

sino que de ella el Cielo por templarte
la vida (deuda a tu pincel) retira.
No el Sol sus rayos por su esfera gira
como en tus lienços, basta el empeñarte
en amagos de Dios, entre a la parte
naturaleza que vencer se mira.
Emulo a Prometeo en un retrato,
no afectes lumbre; el hurto vital dexa
que hasta mi alma a tanto ser ayuda.
Y contra veinte y nueve años de trato,
 entre tu mano y la de Dios, perplexa,
 qual es el cuerpo en que ha de vivir duda.

To the same Greek, in a portrait that he did of the author: 'O divine Greek! No one will reproach your picture for the fact that in its image art surpasses reality, rather they will reproach heaven that it should stay your hand from diverting to your brush the life heaven itself owes. The sun in its orbit does not emit such glorious beams as in your canvases. You need only to play at being God and Nature joins in your game and sees herself defeated. As you emulate Prometheus with your portrait, do not simulate the fire, cease to steal from life, whatever the longings of my soul, for after twenty-nine years it stands perplexed between your hand and the hand of God, uncertain which body it should inhabit.'

A un rayo, que entró en el aposento de un pintor

 Ya fuese fuego o pluvia, o ya cuidado
 que émulo tu pincel de mayor vida,
 le diese a Jobe, nieve vi encendida
 el taller de tus tintas ilustrado.
 Ya sea que el laurel honor sagrado
 guardó la lumbre ya que reprimida,
 la saña fué de imagen parecida
 desvaneció el estruendo, venció el hado.

No por tus lienzos perdonó a Toledo,
el triunfador del Asia antes mas dueño,
governaste del cielo los enojos.
Embidia los mostró, templólos miedo,
y el triunfo tuyo su castigo, o ceño
hiziste insignia quando no despojos.

To a ray of light entering a painter's room: 'Whether it was fire or
rain, or care for a greater life, that your rival brush offered to
Zeus, I saw the snow on fire and your studio lit up with your own
colours. Or the sacred laurel may have kept the flame alight when
it was already bound to die; the lightning flash was like an image,
uproar paled away and destiny conquered. It was not because of
your pictures that the conqueror of Asia forgave Toledo, no, it
was you who mastered the wrath of the heavens and tamed them.
What was founded in envy was weakened by fear, and you made
of your triumph, their punishment and their anger, a banner and
rich spoils.'

Al túmulo deste mismo pintor, que era el Griego de Toledo

Del Griego aquí lo que encerrarse pudo
yace, piedad lo esconde, fee lo sella,
blando le oprime, blando mientras huella
çafir la parte que se hurtó del nudo
Su fama el Orbe no reserva mudo
humano clima, bien que a obscurecella,
se arma una embidia, y otra tanta estrella,
nieblas no atiende de Orizonte rudo.
Obró a siglo mayor, mayor Apeles,
no el aplauso venal, y su extrañeza
admirarán no imitarán edades.
Creta le dió la vida y los pinceles,
Toledo mejor patria donde empieza
a lograr con la Muerte eternidades.

236

To the tomb of this same painter, the Greek of Toledo: 'Here lies the Greek, that part of him that can be confined, wrapped tenderly in piety and gently swathed in faith, while that part of him that has fled the confining world floods the azure skies. Envy takes arms to dull his fame, yet it is spoken out loud in the world of men, for such a bright star is untarnished by mists on the rough horizon. Greater than Apelles, he worked, not for venal glory, but for a greater century to come; future ages will admire his distinction but not equal it. Crete gave him his life and his brushes, but Toledo gave him a better land where, in death, he achieves eternal life.'

El Greco and Spain

Spain reacted in a quite distinctive way to the Renaissance. The movement did not seem to appeal to the temperament of the Spanish people. Previously the various primitive schools of Catalonia, Aragon, the Levant, Andalusia, Navarre and Castille had developed very much in parallel with Italian, Provençal, Flemish and Rhenish painting, responding in a similar way because the problems they faced were the same, although the Spanish schools tended to employ original forms and powerful drawing techniques. But in the sixteenth century the dialogue was abruptly broken off. It was not for lack of contacts with the rest of Europe, there was clearly a real opposition between the Spanish temperament and the wave of humanism and pagan feeling that swept through Italy. The Spanish artist never abandoned himself to the intoxication of exploring ideal or natural beauty in its most basic state, of uncovering full and seductive forms. He felt he had to conquer the flesh, torment forms in order to make them express the terrible ideas and bitter thoughts of his own anguish and despair. Of course, Spanish painters went abroad to study under the great masters. They even deployed their considerable technical resources in faithfully copying the lessons they had learned, yet as soon as they returned to Spain they were caught up again in their powerful society and succumbed to its dictates. Pedro Berruguete, for example,

did not find his newly acquired knowledge tempered his mysticism or made it more humane, rather it grew even more intense and fanatical. The naive representations of medieval piety were not abandoned as having served their purpose, but integrated into a stricter organization to make them even better instruments of faith. The first painters who did succumb to the temptations of full and rounded forms (the usual and by no means the best legacy by Leonardo da Vinci) were rescued from insipidity and mawkishness by their primitive robustness. This quality was an enduring feature of Spanish art and tended to express itself in a taste for large cubic planes that were particularly suited to constructions of strong colour and contrast, of infinitely greater richness than effects achieved by chiaroscuro. The Sevillian painters, reared in a city that had once before proved receptive to the influence of Flanders, were the most fervent supporters of Italian taste, yet even they did not allow themselves to be confined for long within narrow limits. Their visionary and exalted temperament safeguarded their originality. So the excesses of Pablo de Cespedes go hand in hand with the most surprising lyricism, as in the *Last Supper* in the Seville Museum; the composition is crowded with incidental details, each individual detail emphasized as an object in its own right, and yet is borne along on a rhythm derived at once from the boldness of the drawing and the strident combinations of the most unlikely colours. In this astounding work, clearly a landmark along the road towards the Romantic visions of Valdés Leal, the distortion of the features and the vivid colouring go beyond all ideas of reason and taste and create

what is virtually a new form of expression. Pachecho himself, who was always so concerned to respect the classical rules and ideals, in his remarkable attempt to define in his many portraits the basic human types characteristic of his age, found himself succumbing little by little to the individual spirit of his models, and escaped from conventionality by stripping away everything that was not essential and true. Although there had never before been so many Italian artists in the peninsula at one time, by reason of the vast enterprises undertaken by Philip II, the very fact that they arrived in small self-sufficient groups made them proof against assimilation and nullified in advance what influence they might have had; this was in complete contrast to the foreigners who arrived in the Middle Ages from Barcelona, Valencia or Seville, Germany, Flanders or Italy, and quickly picked up Spanish habits and established fruitful relationships with their new colleagues.

At the price of this conscious impoverishment and refusal to participate, Spanish art of the sixteenth century probably averted the danger to which it, in a citadel of the faith, would have been most likely to succumb. The Council of Trent, in which Spanish prelates took a major part, had proposed, indeed virtually imposed, an official iconography for Catholic countries; this meant that anything that was not sanctioned as historical fact by the official texts of the Holy Books had to be abandoned. The result was that the artist became in effect the servant of the theologian, obliged to follow the Church's teaching in every respect for the greater glory and edification of the faithful. Normally one would have assumed that this would end in

a strict and cramping Academism, which would dismiss the great contributions of Leonardo da Vinci, Raphael and Michelangelo, and retain only the most conventionally useful elements. Spain more than any other nation ran the risk of succumbing to a yoke of uniformity. It was the independence and originality of her painters that saved her, their inability to adapt themselves to over-generalized forms, the obligation they felt to rethink the great problems on a more intimate, more personal and more human scale. And above all she was saved by El Greco.

It was the existence, at the very heart of Spanish culture, of the immortal works and dominating personality of the Greek from Toledo that ensured that Spanish art did not remain sunk in a sound but limited provincialism, but suddenly found itself in touch with the most significant experiments conducted beyond her frontiers, linked once again with its distant origins (for Spain had responded once before to the call of the East) as well as with the logical and humanistic mainstream of Western thought. The seeds of the most fertile conflicts and problems of modern expression were already contained within the work of El Greco. Having experienced at first hand the glories of Venice and acquired the basic elements of Roman Mannerism, he brought with him the best ideas and techniques Italy had to offer. Yet his practice of assimilating new ideas in a very personal way meant that he had, as it were, restored the words of the language to their original meaning. Influenced as he was by Byzantine forms, he knew the advantages of coherent systems of thought, but he also knew from personal experience the poten-

tial aridity of an art based on formulas and types. Spurred on by the proud consciousness of his own genius, he would accept ideas from other sources only if he could give them new life in terms of his own experience. So his art is a fusion of many of the new directions in the art of his day, but always fully assimilated, personally realized and followed through to their ultimate logical expression.

El Greco was also unusually receptive to ideas of the past. He had a very profound sense of the community of cultures and the eternal validity of certain values. His architectural knowledge made him believe in the need for a guiding conceptual unity. His work has obvious parallels with the vast cosmic representations of the Middle Ages; he was not the man to be carried away by the myth of boundless progress, which would free man from his subjection and make him the centre of the universe. His work is a miraculous marriage of heaven and earth, showing humanity seeking to know its density in the world beyond death, and receiving a response from a benevolent divinity. His idealized figures are never cold or distant creatures; even the colours of their decomposition are borrowed from the world of the flesh, but they are not restricted to any physical likeness. There is a basic underlying unity between the substances and structures of the real and the supernatural worlds, and there is hardly one major composition in which El Greco does not resolve the duality of his conception by representing both worlds in terms of the same all-pervading atmosphere. The *Burial of the Count of Orgaz* remains the most perfect example of the simultaneous view of two zones of

creation, and manifestly it is quite wrong to view the lower section in isolation, as for example in the copies made by Jorge Manuel and in some photographic reproductions. The more so because the fusion of the two worlds is realized on every level of the composition, not only in the complete naturalness with which the shining visions of the saints appear amongst the living, but also in the inspiration of the faces as they look up towards heaven.

Yet even in his most subjective creations, El Greco is not without a sort of guiding spirit of objectivity. As his forms become more exalted, his points of reference in the surrounding world become more precise. The period when he painted his great compositions was also the time when he produced most of his portraits, and it can hardly be in doubt that these represent a search for the same truth from a different direction. If this area of his work appeals today as being more modern, it is simply because it is a more direct statement of a certain approach to the interpretation of forms, although even the portraits are conceived of in terms of inward, as well as outward, truth. The faces, often expressed in a few essential strokes, are vibrant with life, but they are far more than an attempt to reproduce a visual likeness. Many are purely imaginary, visions of the soul supplying features for men whom the painter remembered only dimly, or indeed for men whom he knew only from the crudest of images. He gives them life, a higher form of life, only by in some way transcending the fact of existence. One has only to compare this category of El Greco's work with the great Venetian school of portraiture, of which it is

supposed to be a logical development, to see the profound differences between them. Portraits by Titian or Tintoretto are magnificently complete syntheses of powerful and solitary personages, locked in their destiny. El Greco's models have a strange, lost quality, they seem suspended between life and death, captured in just the moment when they are most intensely themselves. Having escaped official recognition and court duties, El Greco painted only people with whom he felt in sympathy: and indeed this is always quite apparent. Rather than merely delineating their features, he tried to fathom what went on in the hidden depths of their being, as well, probably, as in the recesses of his own mind. Hence no doubt the haunting similarity of faces which in other respects are so strongly individualized. They express something of the spirit of El Greco, and it is his quality of mysticism, his melancholy, his blend of penetration and bewilderment, that give them such an urgent and appealing sense of life. I believe that El Greco was the first painter to bare his soul in this way.

In the technical sphere too, El Greco demonstrated his ability to combine the best of what already existed with extraordinary innovations of his own. Colour was for him an essential element both in design and construction; it therefore obeyed the rules of its own inner logic and was totally unconnected with the real world. His apparent preference for the cold colour range of the Mannerists, rather than the warm and golden blends of the Venetians, was derived from his respect for pure colours and his consciousness that they could be juxtaposed to much greater effect.

Although he did use large, uniform planes of colour, he never left them in that cold, dead, varnished state characteristic of Mannerist paintings; they were little more than grounds, preliminary surfaces, often of tempera, to which vigorous strokes or dabs of pure colour were added later, in oils, to give an effect of vibration, movement and life. His contemporaries, as Pachecho noted, were stupefied by his methods, which seemed to call in question the very existence and superiority of the finished work of art. Poets, like Paravicino in particular, were better able to understand that the work of art, by remaining flexible, so that it could take on different appearances according to whether it was viewed from near at hand or at the distance necessary for the optical mix to operate, actually gained in freedom and precision, adapting itself to the viewpoint of the individual beholder. What seemed to Pachecho no more than a device to give the illusion of vigour to a work that was already finished, and which he therefore regarded as immutable, was in fact a superb demonstration of El Greco's infinitely subtle ability to represent light and accurately interpret nature.

His method of situating forms in space owes even less to the classical approach. As a good Byzantine, El Greco regarded painting as being above all an art of surfaces. He therefore rejected out of hand any procedure that would tend to create an illusion of three-dimensionality, any *trompe-l'œil* technique. Instead he conveyed the impression of depth by introducing distortions, the elongation of the forms being determined by the vanishing point, placed low in the picture.

El Greco's Twentieth-Century Reputation

El Greco achieved fame and glory in his lifetime, and his reputation, although somewhat dimmed in the last few years of his life, was again revived in the seventeenth century. Velasquez, who had seen works by Tristán in Seville and must have heard Pachecho, his father-in-law, talk about El Greco, went to Toledo to purchase some of El Greco's religious paintings and portraits for the Royal Collection, for which, as court painter, he was responsible. This is how the Prado acquired the splendid portraits in its possession today. We know that Velasquez kept them in his studio for some time, and the direct influence of these portraits is apparent in some of his finest works; the handling of the famous *Portrait of Pope Innocent X* is clearly inspired by the carmines of the papal robe in El Greco's portrait of *Cardinal Fernando Niño de Guevara*. The *St Paul* and *St Eugene* in the Escorial also have their origins in purchases made by Velasquez.

After an artist's death there is almost always a period when his works falls into neglect. El Greco is no exception to this general rule, but he has in addition been subjected to a campaign of systematic criticism reaching quite unjust proportions. It started with the opinion expressed by Palomino, the Vasari of Spain, that El Greco's late manner was extravagant 'with dislocated drawings and disagreeable colours'; this became *the* criticism of historians and writers for many years to

come. The next stage was that attempts were made to justify these extravagances and the other anomalies of this body of work, which is admittedly without parallel, by guessing the reasons that could have influenced him to paint and view things as he did. Out of this grew the legend of his madness, and soon the most ingenious minds began to advance the theory that he suffered from some form of defective vision. Nobody could believe that the characteristic features of his work were quite intentional and corresponded to deliberate and conscious ideas, far in advance of their time. Such, no doubt, is the fate of all true prophets.

Thus travestied, the figure of El Greco was a prime candidate for the role of romantic hero and, paradoxically, this only served to enhance his later fame. A mad unrecognized genius, a rootless outcast, a demon of the law-courts, an extravagant recluse who, faced with general incomprehension, sank into a state of despair. Discussed in these terms, his character again became a topic of interest, and his work, although scorned by the Spanish Academic painters of the nineteenth century, did not escape the notice of the French Romantics travelling in Spain. The French obtained many pictures during and after the Napoleonic Wars, and the Carlist Wars, as well as in the course of the thriving trade that went on at that time between Spain and the South of France. Baron Taylor, entrusted by Louis Philippe with the task of buying pictures to form the basis of a Spanish collection, was well aware of El Greco's importance. His colleague, the Orientalist painter Dauzats, managed to acquire in Toledo nine first-class pictures that came originally from convents that had been suppressed or

pulled down; these included the *Crucifixion with Donors* now in the Louvre, and a number of other paintings that later passed into the Romanian Royal Collection. These works do not seem to have attracted much attention from the visitors to the Spanish Gallery, with the single exception of the portrait of the *Lady in a Fur Wrap* which aroused great curiosity concerning the details of El Greco's life with his enigmatic companion. The painting was reproduced in the *Magasin pittoresque* and inspired the young Cézanne to paint a picture on the same theme.

It was, not surprisingly, the painters, poets and critics who, in marked contrast to the general public, sprang to the defence of El Greco's work. Théophile Gautier, who visited Toledo in 1840, was profoundly moved by the fine pictures in the Hospital Tavera, the touching portrayal of the Virgin in the *Holy Family*, and the *Baptism*. True he stirred up all the old legends, but he did at least interpret them in a fairly positive way, speaking of 'a depraved energy, a morbid power, which is always startling and kindles the imagination'. Baudelaire was a regular visitor to the Spanish Gallery and particularly liked the El Grecos. He presumably talked of them to Manet and Zacharie Astruc, who then mentioned them to Cézanne. An El Greco even found its way into Millet's hands and was later bought from him by Degas. Théodore Duret, Paul Mantz, Manzi and Rouart, all commented on this work.

But it was not until early in the twentieth century that El Greco's reputation was restored to all its former glory, for it was then that he achieved recognition in his adoptive country.

The decadence of Toledo and the amazing flowering of El Greco's art amid all this austerity and gloom took on a symbolic significance for the Spanish writers of the great 'Generation of 1898', who were haunted by the problems facing contemporary Spain, ruined by the loss of her last American colonies and trying to recover her former greatness and establish her position in the world. For Unamuno, Pio Baroja, Azorin and Cossío, Toledo and the story of El Greco were symbols of hope. Cossío wrote a major work on the painter, which was published in 1908. Before that, in 1902, the first major exhibition of El Greco's work had been held, in the Prado, and the catalogue was written by S. Vinegra. Another exhibition was held in Paris, at the Salon d'Automne of 1918, organized by Paul Lafond, curator of the Musée de Pau. Cossío's seminal book was supplemented, in 1910, by the publication of *El Greco de Toledo*, based on research carried out in the archives of Toledo by Francisco de Borja de San Román y Fernández: this was followed by many other books from the same author. At about the same time, largely thanks to the efforts of the Marquis of Vega Inclán, work was started on an intelligently planned reconstruction of El Greco's house, which was to become a museum and contain an important collection of his major works; the site was one of the famous houses of the Marquis of Villena, where El Greco's original house had stood. Unfortunately this was also the period when the great altarpieces of Santo Domingo el Antiguo and the Chapel of San José were broken up, so that today the component paintings are dispersed over several continents.

All this while El Greco's habit of distorting his figures continued to give rise to theories and explanations of a medical nature. Oculists announced that the key to his art was severe astigmatism, and that this was the reason for his elongated faces, his levitating bodies and his staring, ecstatic eyes. These explanations are patently absurd, especially when one takes into account that El Greco, when he wanted to, reproduced with all the precision of a primitive painter those details of landscapes or settings which he regarded as being particularly important. Doctors maintained that his images were like hallucinations produced under the influence of drugs such as hashish. Even Gregorio Marañon, in the course of a rather more subtle analysis of El Greco's character, described him as a classic case of asthenic hyperthyroid, alternating between chemically induced depression and unnatural exaltation and heightened activity.

In the end, other painters played a key role in El Greco's revival this time Spaniards making amends for the ingratitude of past generations. In 1893–94, the Catalan painter Santiago Rusiñol and his Basque colleague Ignacio Zuloaga, who had studios in Paris and divided their time between France and their native country, became very interested in the work and personality of El Greco. Picasso, in his blue period, succumbed to the same spell. At Zuloaga's instigation, Rusiñol bought two El Grecos from a penniless old Spanish artist living in Paris, and these aroused the admiration of the French painters and writers who were among their friends. The paintings were taken to Barcelona and then to Rusiñol's house in Sitges, where

they were intended to remain, like a shrine, at which pilgrims came to worship in the grand Wagnerian style that was popular in the Catalan capital at that time. Later a statue of El Greco was erected on the site.

In the meantime Ignacio Zuloaga managed to acquire several memorable works by El Greco, notably *The Fifth Seal of the Apocalypse* of his last period. These paintings were transferred to Zumaya, his home in the Basque country, later turned into a museum (although by then it was no longer graced by the *Apocalypse*, which had been bought by the Metropolitan Museum of Art, New York). It was in Zumaya that Maurice Barrès, travelling from San Sebastián, first discovered the work of El Greco, which was to be such a great inspiration for his own work. His book undoubtedly owes a great deal to the advice and ideas of Zuloaga who became his friend and, in 1913, painted a portrait of him standing in front of a panoramic view of Toledo, rather in the manner of the portrait of Jorge Manuel in front of a view of the town. It was Barrès' book, *Greco ou le secret de Tolède*, that at long last introduced El Greco to a wider international audience. In spite of small errors of fact, since corrected, and a tendency to over-identify the artist with Toledan society, this book by Barrès is an analysis of the painter's works, attitudes and distinctive contribution, that is still remarkable in the history of painting. This is how Barrès describes the Virgin in the *Assumption*: 'A queen surrounded by her pages, ravishing in her nobility and universally adored, she is like a voice, a vibrant song, or rather, a trembling respite in mid-dance.' And of the noblemen of Toledo: 'Behold their noblest desires reaching up to heaven;

were it not for El Greco and the rapture of his painting, none of these souls would have been preserved from death. Each amazing figure possesses in the depths of his consciousness the same principle of hope, ardour and detached calm. They are beings who derive their life from a divine source. See how they cling to God. As they are drawn to Him, so they draw Him down.' But Barrès, who was not well informed about the developments in painting in his own day, did not realize how closely El Greco's aesthetics corresponded to the principles recently devised by Cézanne, Gauguin and Van Gogh, and which were to be fundamental to their radical new approach to painting; these modern principles were, precisely, the primacy of colour, the reduction of forms to strong rhythmic patterns and basic geometrical figures, and an emphasis on subjective expression.

El Greco's prophetic insights lie at the heart of his greatness. Ramón Gómez de la Serna wrote of him that his colouring expressed 'a sure and profound eloquence, sometimes as trenchant as a knife, the knife of the soul that strips the figures bare by freeing them of all superfluous details'.

Paul Claudel, Jean Cocteau and Eugène Dabit paid homage to him in their works. And, finally, it is El Greco the man who is singled out for praise. 'The elegance of Velasquez consists in his absence from the picture', wrote José Ortega y Gasset, and: 'El Greco's paintings are a ceaseless exteriorization of himself. When we look at an El Greco painting, what we see is El Greco. His style is his confession and his message.'

List of Illustrations

c. 1610
Oil on canvas, 90 × 61 cm
Coolidge collection,
Topsfield, Mass.

51 St Mary Magdalen in
Penitence 1580–85
Oil on panel, 60 × 42 cm
Private collection, Murcia

52 St Mary Magdalen in
Penitence 1580–85
Oil on canvas, 104 × 85 cm
W. Rockhill Nelson
Gallery of Art, Kansas
City, Mo.

53 St Catherine of Alexandria
1580–85
Oil on canvas, 100 × 77 cm
Museo del Cau Ferrat,
Sitges

54 St Veronica 1580
Oil on canvas,
105 × 108 cm
Caturla collection, Madrid

55 St Veronica 1580–85
Oil on canvas,
103 × 79.2 cm
Alte Pinakothek, Munich

56 St Veronica 1580–85
Oil on canvas, 105 × 79 cm
B. del Carril collection,
Buenos Aires

57 Appearance of the Resurrected
Christ to the Virgin 1580–85
Oil on canvas, 24 × 21 cm
Royal Palace, Sinaïa,
Romania

58 Appearance of the Resurrected
Christ to the Virgin 1580–85
Oil on canvas,
100 × 118 cm

Boymans-van Beuningen
Museum, Rotterdam

59 St Francis in Meditation
1585–90
Oil on canvas, 105 × 87 cm
San Diego, Calif.

60 St Francis in Meditation
1585–95
Oil on canvas, 90 × 70 cm
Hospital Tavera, Toledo

61 Duke of Benavente 1585
Oil on canvas, 101 × 76 cm
Musée Bonnat, Bayonne

62 Christ on the Cross 1585–90
Oil on canvas,
250 × 180 cm
Musée du Louvre, Paris

63 Christ on the Cross 1585–95
Oil on canvas,
177 × 105 cm
Zuloaga collection,
Zumaya

64–73 Burial of the Count of
Orgaz 1586–88
Oil on canvas,
460 × 360 cm
Santo Tomé, Toledo

74 Julián Romero de las Azañas
and St Julian (or St
Theodore, or St Louis)
1585–90
Oil on canvas, 46 × 53 cm
Museo del Prado, Madrid

75 Rodrigo de la Fuente (The
Doctor) 1585–89
Oil on canvas, 93 × 82 cm
Museo del Prado, Madrid

76 Don Rodrigo Vázquez
1585–90

Oil on canvas, 62 × 40 cm
Museo del Prado, Madrid

77 The Holy Family with
St Anne c. 1585
Oil on canvas,
127 × 106 cm
Hospital Tavera, Toledo

78 The Holy Family with
St Anne
(detail of ill. 77)

79 St James the Greater c. 160
Oil on canvas,
102.5 × 83 cm
Kunstmuseum, Basle

80 St Francis and Friar Leo
Meditating on Death c. 159
Oil on canvas,
152 × 113 cm
Museo del Prado, Madrid

81 St Francis in Ecstasy 1590–
Oil on canvas, 75 × 57 cm
Musée des Beaux-Arts, P

82 St Francis in Meditation
1590–95
Oil on canvas, 122 × 97 c
Musée des Beaux-Arts, Li

83 St Peter in Tears 1585–95
Oil on canvas, 102 × 84 c
Hospital Tavera, Toledo

84 St Peter in Tears 1585–95
Oil on canvas, 93 × 75 cm
Niarchos collection, Pari

85 St Peter in Tears 1585–95
top left
Oil on canvas, 102 × 84 c
Hospital Tavera, Toledo

86 St Peter in Tears 1585–95
top right

Illescas

112 *St Martin and the Beggar*
1597–99
Oil on canvas,
193.5 × 103 cm
National Gallery of Art,
Washington, DC

113 *Purification of the Temple*
c. 1600
Oil on canvas,
106.3 × 129.7 cm
National Gallery, London

114 *Agony in the Garden c.* 1605
Oil on canvas, 161 × 91 cm
Musée des Beaux-Arts, Lille

115 *Madonna and Child with*
St Agnes and St Martina
1597–99
Oil on canvas,
193.5 × 103 cm
National Gallery of Art,
Washington, DC

116 *Purification of the Temple*
1595–1605
Oil on canvas,
41.9 × 52.4 cm
Frick collection, New York

117 *St Bernardine* 1603
Oil on canvas,
269 × 144 cm
Museo del Greco, Toledo

118 *Apparition of the Virgin and*
Child to St Hyacinth
1605–10
Oil on canvas, 158 × 98 cm
Barnes Foundation,
Merion, Pa.

119 *Baptism* 1608–14
Oil on canvas,
330 × 211 cm

Hospital Tavera, Toledo

120 *Baptism c.* 1600
Oil on canvas,
350 × 144 cm
Museo del Prado, Madrid

121 *Annunciation* 1608–14
Oil on canvas,
291 × 205 cm
Urquijo collection,
Madrid

122 *Resurrection* 1605–10
Oil on canvas,
275 × 127 cm
Museo del Prado, Madrid

123 *Pentecost* 1605–10
Oil on canvas,
275 × 127 cm
Museo del Prado, Madrid

124 *St Jerome as Cardinal*
1604–10
Oil on canvas, 108 × 87 cm
Metropolitan Museum,
New York, Lehman
collection

125 *St Ildefonsus* 1605–10
Oil on canvas,
187 × 120 cm
Hospital de la Caridad,
Illescas

126 *St Ildefonsus* 1605–10
Oil on canvas,
222 × 105 cm
El Escorial

127 *The Assumption*
(Immaculate Conception)
1608–13
Oil on canvas,
347 × 174 cm
Museo de Santa Cruz,
Toledo

128 *Christ in the House of Sim*
1605–14
Oil on canvas,
143 × 100 cm
Art Institute of Chicago,
Chicago, Ill.

129 *St Peter* 1605–10
Oil on canvas,
207 × 105 cm
El Escorial

130 *St Sebastian* 1610–14
Oil on canvas, 115 × 85
Museo del Prado, Madri

131 *St John the Evangelist and*
St John the Baptist 1605–
Oil on canvas, 110 × 87
Museo de Santa Cruz,
Toledo

132 *St Jerome in Penitence*
1612–14
Oil on canvas,
168 × 110.5 cm
National Gallery of Art,
Washington, DC

133 *Laocoön c.* 1609
Oil on canvas,
137.5 × 172.5 cm
National Gallery of Art,
Washington, DC

134 *Adoration of the Shepherd*
1612–14
Oil on canvas,
319 × 180 cm
Museo del Prado, Madri

135 *Purification of the Temple*
1610–14
Oil on canvas,
106 × 104 cm
San Ginés, Madrid

136 *View of Toledo* 1595–161
Oil on canvas,

258

259

Photographic Acknowledgments

Bulloz: 73, 80, 93, 94, 123, 130, 140, 167; Colorphoto Hans Hinz, Basle: 33, 97, 111, 168, 169, 171, 174, 201; Giraudon: 29, 32, 40, 47, 74, 78, 89, 95, 99, 102, 103, 106, 108, 109, 113, 114, 115, 116, 120, 125, 136, 150, 156, 159, 162, 163, 183, 184, 187, 190, 192, 194, 200, 206, 209, 215; Lauros-Giraudon: 70, 96, 126, 134, 138, 144, 148, 149, 186, 203; Mas, Barcelona: 15, 17, 19, 20, 21, 22, 24, 25, 36, 37, 52, 62, 63, 64, 65, 66, 69, 75, 76, 79, 82, 85, 86, 88, 92, 117, 119, 129, 158, 161, 172, 177, 188, 189, 198, 199, 217, 233; National Gallery of Art, Washington: 28, 154, 157, 178, 180; Roger-Viollet: 50, 100, 101, 144, 155, 207.

Printed by Printer Industria Gráfica S. A. Depósito legal B. 41131-1973